IMAGES
of America

DENVER'S
WASHINGTON PARK

IMAGES
of America

DENVER'S
WASHINGTON PARK

Sarah O. McCarthy

ARCADIA
PUBLISHING

Published by Arcadia Publishing
Charleston, South Carolina

Printed in the United States of America

Library of Congress Control Number: 2013952336

For all general information, please contact Arcadia Publishing:
Telephone 843-853-2070
Fax 843-853-0044
E-mail sales@arcadiapublishing.com
For customer service and orders:
Toll-Free 1-888-313-2665

Visit us on the Internet at www.arcadiapublishing.com

Insufficient credit is given to neighborhood volunteers like Gertie Grant and Charlotte Winzenburg whose time and talents make Denver a wonderful place to live.

CONTENTS

ACKNOWLEDGMENTS

No successful project is completed alone. I am one of a large team that has helped to gather this collection of images of Washington Park and its environs. The first to recognize for his contributions is Paul Kashmann, editor of the *Washington Park Profile*, for his graciousness in sharing 35 years of images of Washington Park and the surrounding area. The professional staff at the Denver Public Library Western History and Genealogy Department is invaluable and good-hearted. These curious souls deserve every penny of Denver taxpayers' support. My thanks go to the staff of History Colorado, who willingly gave their assistance to find just the right document or image to improve this book's content.

Royal Crest Dairy's owner and staff welcomed my request to share their business story, and I thank them for allowing me use of their company images. To Denver Public Schools facility-management staff—and to Steele Elementary School's staff in particular—go my thanks for trusting me with their images and for their ongoing stewardship of our remarkable public assets. My sincere thanks also go to the many volunteers of the South High School Alumni Association for opening their treasure trove of photographs, which span 85 years.

The following individuals willingly shared portions of their family histories to be included in this collection: Thanks go to Nita Jean Molberg, the Chuck Bushman family, and the Bill Hughes family for taking the time to allow me a glimpse into their stories of living and working in Washington Park. Special thanks are extended to Barbara Froula for the use of one of her iconic drawings of Washington Park.

I am indebted to the following noted historians and preservationists for their guidance and generous support on my preservation travels: Barbara Norgren, Tom Noel, Jennifer Moulton, James Stratis, Everett Shigetta, and Barbara Sudler Hornby. To Ann and Dave Student, I offer my gratitude for their time, images, and wisdom on both compiling books and Denver's history.

My thanks go to local authors Millie Van Wyke, Phil Goodstein, and Nancy Widmann for their research and documentation of South Denver and Washington Park's colorful past. Their work supplied many details of this area's history so I might better tell this story through pictures. Any and all errors are mine and only mine.

My deepest thanks go to my family for being in my life and for their support and encouragement in my pursuit of new endeavors. I know, without doubt, that they have been behind me all the way.

INTRODUCTION

One and a half centuries ago, groups of white men headed west, either to find gold or to supply the hopeful miners with the goods and services they would need. They learned the hard lessons of settling near Colorado's seemingly placid creeks and rivers. Four miles southeast of the junction of the South Platte River and Cherry Creek is high ground; this land area became South Denver in the 1880s and is generally known today as Washington Park. For the purposes of this book, the boundaries of inclusion start in the northwest at Broadway and the Cherry Creek, proceed south along Broadway to what is now Interstate 25 (formerly part of the Denver & New Orleans Railroad route), travel east along this corridor to University Boulevard, and proceed north to Cherry Creek.

In the early 1860s, three men who would be instrumental in establishing South Denver's community culture and quality of life settled along the banks of the South Platte River with their families. William N. Byers, John W. Smith, and Rufus Clark, among others, worked to resolve the issue of getting water to areas east of the Platte River by completing Smith's Ditch, which allowed newcomers to make their homes and lives here.

After Smith finished his 25-mile-long, meandering ditch that allowed Clark to plant fields of potatoes on land irrigated by ditch water, others took it upon themselves to relieve congestion on the Santa Fe Trail, the only improved route from the south to Denver. Local farmers carved out a new route, Broadway. Once the busiest roadway in Colorado, it extends more than 20 miles from north to south and serves as the east-west divider in the burgeoning Denver metropolitan area. With Broadway graded, a bridge was needed to cross Cherry Creek. Again, it was local residents—not the county or city government—that took action, laying planks that repeatedly got washed away in periodic floods.

Most of the men and women establishing their homes in what became South Denver were shop or factory owners—not the same class of people who built mansions on Capitol Hill. These were typical businessmen and -women who lived where they worked, favored clean air and pure water, and developed ways to sustain the desired quality of life that benefitted others as much as themselves. To many in the South Broadway Union Club or the South Side Improvement Society, that meant no liquor establishments. These were people who took initiative when the vitality and desirability of their community was threatened. They planted trees beside the roads, started a town government, established school districts, and made plans for a central park.

The area closest to Broadway, viewed in chapter one, developed first with homes, businesses, schools, and churches. As the decades passed, the development kept moving east and south. Chapter two follows the lines of that progression. For 40 years, the neighborhoods surrounding Washington Park were grateful recipients of the public investment implementing Denver's version of the City Beautiful Movement, which was fostered early in the 20th century by Mayor Speer. Many elements of the movement remain evident in and around the park and continue to benefit current residents. There is a strong sense of community in these neighborhoods. The history,

traditions, rituals, and rivalries alive in South High School contribute to the sense of belonging that is palpable today in this virtual small town.

The high ground near the few natural local waterways, the mountain views, and the central location as Denver developed in all four directions have made Washington Park a desirable place to live for 130 years. With popularity come pressures, and not all times have been good in this community of neighborhoods. There were shenanigans along the way, beginning in the 1880s. There have been questionable election results as well as preferential treatment or plum appointments for people with friends in the right places. A firehouse and other structures have been demolished in the "dark of night," residential streets have been converted to thoroughfares of speeding cars over one weekend, and zoning changes have pitted neighbor against neighbor and the ever-present developer. Yet, on the whole, most of the residents have flourished from the efforts of South Denver activists and made a good life here (except, perhaps, for liquor establishments).

Life is a series of interconnected stories about who we are, where we come from, and what it takes to survive. It is not easy to tell the story of 130 years of activism in fewer than 130 pages; however, these snapshots will hopefully instill in the reader a sense of the power and influence that comes of taking action as well as its enduring impact on a community's quality of life.

One

BROADWAY TERRACE

Montana City was settled along the east bank of the Platte River around 1858 but was quickly abandoned. John W. Smith soon collaborated with Rufus Clark in the area east of the Platte to grow produce. The building of the short-lived National Mining & Exposition Hall brought attention, early development efforts, and saloons to the open land south of Cherry Creek. Nascent Broadway early became the route for pioneering rapid transit efforts that started with horsecar service.

Businessmen of smaller enterprises chose to move south of Cherry Creek. This merchant class, not as wealthy as the mansion builders of Capitol Hill, erected smaller, less palatial—but still elaborate—homes. However, very soon, commerce moved down Broadway, replacing these residences with business frontages and shops. As development pushed east, subsequent building in a mix of architectural styles now makes these neighborhoods walkable and interesting places to live and work. There were Queen Anne, Denver Square, Cottage, and eventually Bungalow edifices built in what became the neighborhoods near Washington Park.

William Byers, cofounder of the *Rocky Mountain News*, settled along the Platte bottom and was flooded out, but he never left South Denver. He built the one truly palatial home, perched on the hill to the east on South Pearl Street; it had a panoramic view from Longs Peak to Pike's Peak. Schools were built beginning in the 1880s, becoming the glue for the community. After the Logan School (now demolished), several others were built—including Sherman School, Lincoln Elementary, Steele Elementary, and then Byers Junior High—on the land that was once Byers's homesite. Also, many of the churches built in these early years remain.

As homebuilding filled in the blocks, this area gradually became less and less agricultural. Soon, it became a neighborhood surrounding a park that would come to define and give it a name: Washington Park.

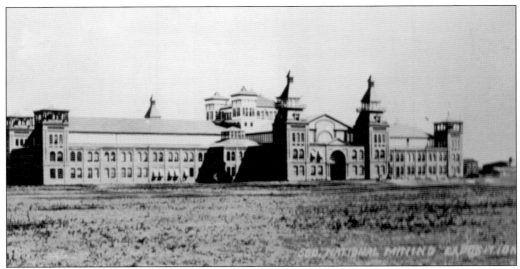

The first promotion of South Denver that received widespread recognition was in 1882 when the National Mining & Exposition Hall opened for annual exhibitions. Exposition Avenue was named for the hall, which was situated along South Broadway at Virginia Avenue. (*Washington Park Profile.*)

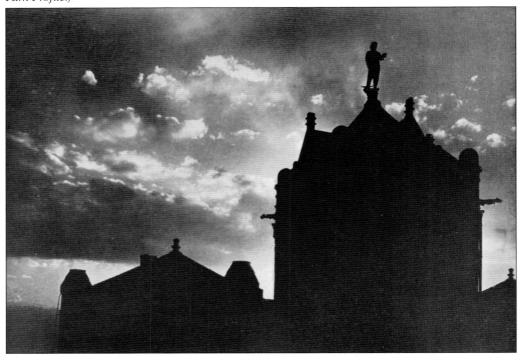

Silhouetted against a Denver sunset, the National Mining & Exposition Hall displayed mining and industrial equipment for three short years, from 1882 to 1884. The multistoried building was composed of towers with belvederes, arcades, pediments, and flags atop cupolas on hipped and gabled roofs. Unfortunately, this hall also represents Denver's fondness for demolition; after only four years of active use, the building was closed and, a short time later, torn down. (*Denver Municipal Facts.*)

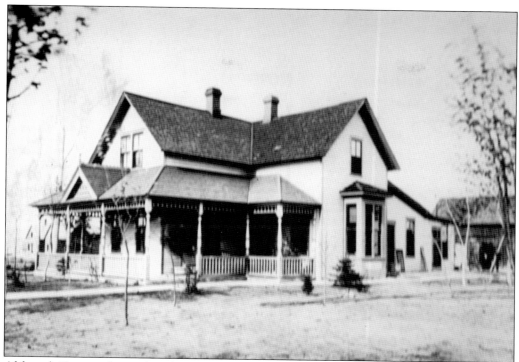

Although Denver changed its fire code, requiring buildings to be constructed of brick after an 1863 fire destroyed much of the downtown area, the remaining original farmhouses in the area south of Cherry Creek are recognizable for their clapboard exteriors. This farmhouse on South Ogden Street at Dakota Avenue remains a residence, but its farmyard is now surrounded by newer houses designed to match the historical clapboard style. (*Washington Park Profile.*)

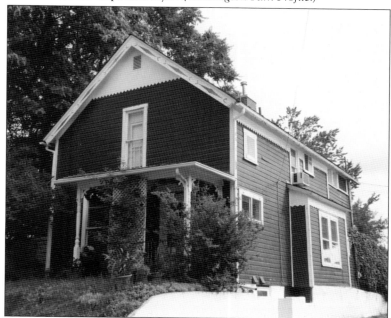

Across what is now Dakota Avenue, the farmhand's house has also survived. Built in 1888, it is now painted a deep red with white trim. Neighborhood lore says that relatives of Jesse James lived here. (Author.)

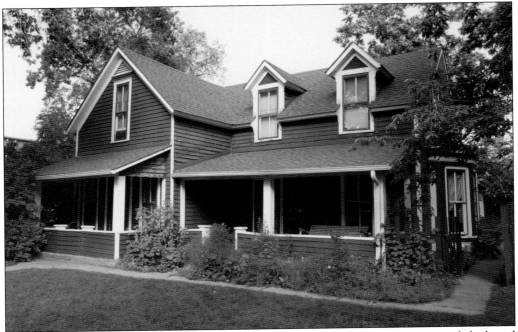

A few blocks north, at 200 South Sherman Street, this 1889 farmhouse of green painted clapboard with white trim has become a local icon. Every fall, a large black macramé spider perches on the roof over the front porch at Halloween. (Author.)

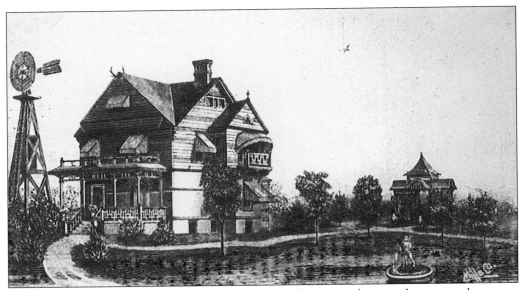

In the mid-1880s, soon after the town's incorporation to keep out saloons and unsavory characters, a building boom came to South Denver. Houses and schools were constructed in quick succession to attract new residents and educate their children. The Abel family residence was built on South Logan Street at Kentucky Avenue. At the time, this area was still rural and the family needed its own windmill. (*South Denver Eye.*)

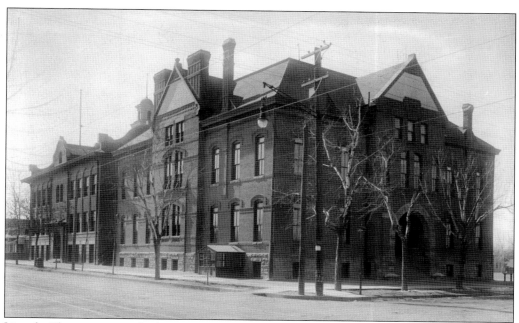

Lincoln Elementary was built in 1891 on South Pearl Street at Exposition Avenue. This is an image of the original building with its 1904 addition. That addition stands as one of the oldest school buildings still owned and operated by Denver Public Schools. No two schools in Denver were designed alike until 1953. (Denver Public Library.)

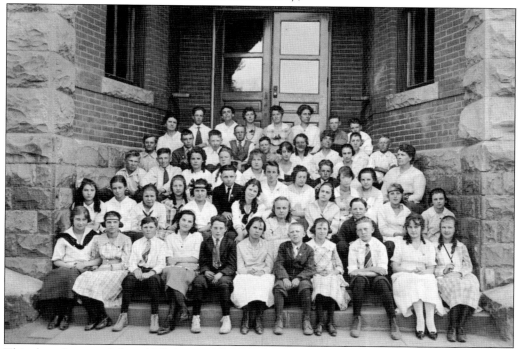

This class photograph from 1919 shows students gathered on the steps of the original Lincoln School, which was demolished in 1929 after another addition was completed. (*Washington Park Profile.*)

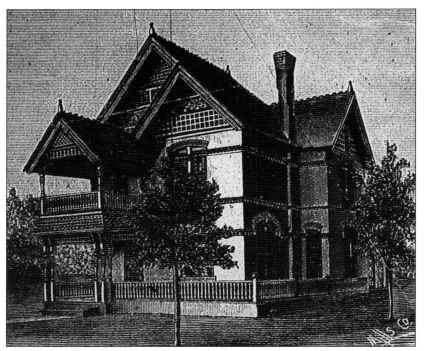

This graceful home was owned by Mrs. G.E. Kettle in 1890 and stands at the corner of Second Avenue and Grant Street. It is a good example of the Queen Anne style with its steeply pitched roof and irregularly shaped, front-facing gable with patterned shingles. (*South Denver Eye.*)

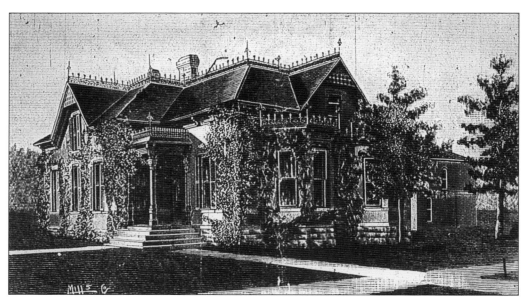

Arthur E. Pierce's home, now a Denver Landmark, was originally designed in a modified Italianate style with an emphasis on vertical proportions, low-hipped roof, bracketed cornice, and richly decorated detailing. The core of this home remains at Ellsworth Avenue on South Lincoln Street. Pierce was a founder and publisher of the *South Denver Eye*, a weekly newspaper that was started in 1886 and continued into the 1920s, serving as a collective voice for residents of South Denver. (*South Denver Eye.*)

Another grand Queen Anne house built in the 1890s and carefully restored stands at 590 South Sherman Street. It sits within the site of the National Mining & Exposition Hall. (Author.)

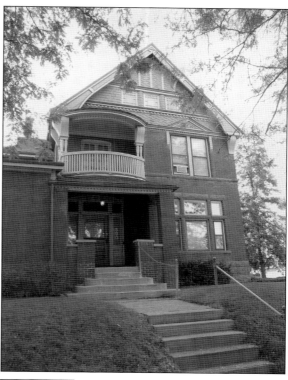

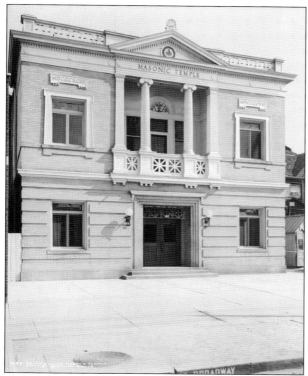

The South Denver Masonic Lodge No. 93 was said to have formed in 1893 around the prescription counter at 434 Broadway. Built in 1907, this structure that stands isolated at 350 South Broadway was designed by the Baerresen Brothers, who also designed the El Jebel Masonic Shrine at Eighteenth Avenue and Sherman Street (listed in the National Register of Historic Places). The Masons open their doors to the community for meetings. (Denver Public Library.)

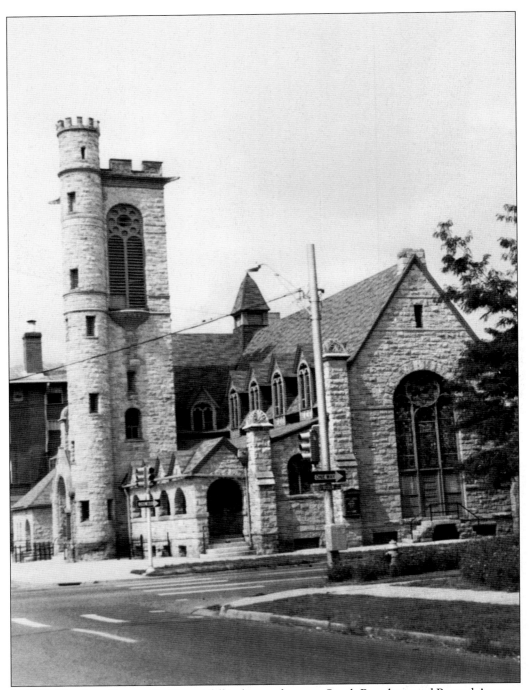

In 1888, Henrietta Sutton died from a fall in her garden near South Broadway and Bayaud Avenue. Her husband, John, was moved to donate all his assets for the creation of a new church—South Broadway Christian Church. He asked only to live out his days in the church's tower. Some say he can still be found gazing lovingly at the glorious flower-design stained-glass windows installed in his wife's memory. (*Washington Park Profile*.)

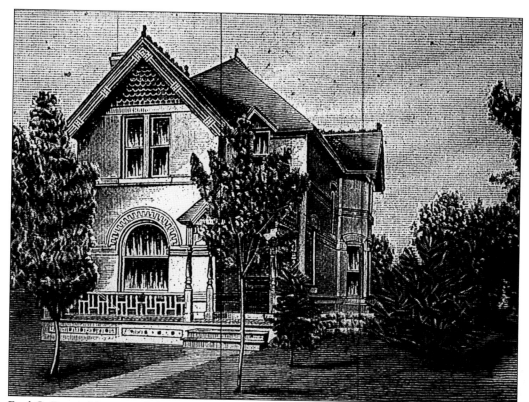

Fred C. Rantschler owned the block on Broadway in which the *South Denver Eye* had its office. He was known as a gentleman of drive and enterprise. His handsome home at the corner of South Sherman Street and Cedar Avenue still stands. Rantschler is remembered for having among the largest and most handsomely kept grounds on the South Side. (*South Denver Eye.*)

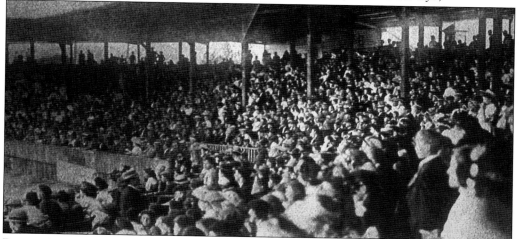

Denver Circle Railroad Company built a baseball park on land across South Broadway from the National Mining & Exposition Hall, and 350 fans watched the first game. Later, the site was known as Union Park, and in 1922 it became Merchants Park, the original home of the Denver Bears baseball team. (*Denver Municipal Facts.*)

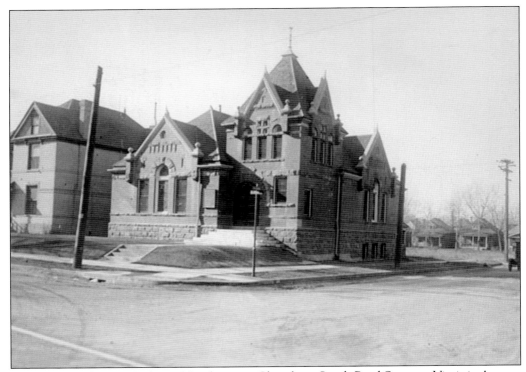

Built in 1893, the First Reformed Presbyterian Church on South Pearl Street at Virginia Avenue is one of the finest examples of Romanesque Revival architecture in the Washington Park neighborhoods. The congregation grew quickly under the leadership of the Reverend James Milligan Wylie, who was active politically. Brian C. Schupbach notes in the 2001 Denver Landmark nomination that Reverend Wylie lobbied the state legislature in 1892–1893 to pass a law narrowly defining marriage to make it "harder to get married in Colorado than anywhere else." (Jerry McElroy.)

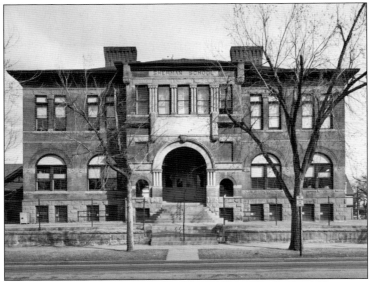

Sherman School was built in 1892 and 1893, also in the Romanesque Revival style, at 208 Grant Street. In 1920, an addition known as the Bungalow Annex was added. The school, seen here without its original tower, was closed in 1982 and is now the home of the Art Students League of Denver. (Denver Public Schools.)

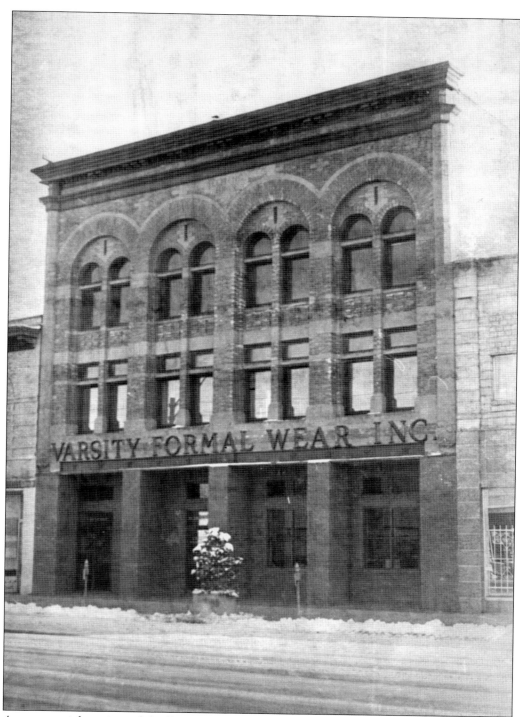

A commercial version of the Romanesque Revival style popular in the late 19th century is evident in this brick-and-stone retail store that has withstood the test of time on South Broadway. (*Washington Park Profile.*)

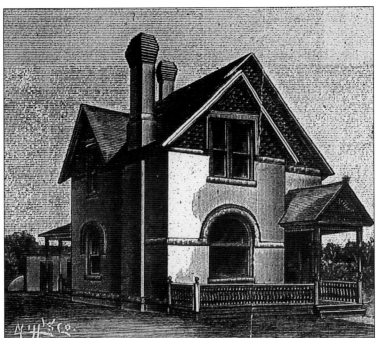

This 1890s house at 277 South Pearl Street was built on speculation and boasts a simplified Queen Anne style. This style is identified by its steeply pitched, irregularly shaped roof and partial-width, one-story front porch, both architectural devices used to avoid a smooth-walled appearance. (*South Denver Eye.*)

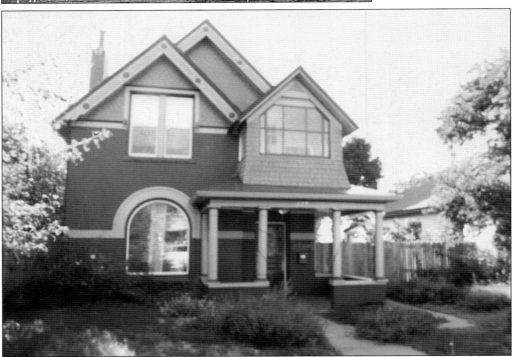

Travelers along South Pearl Street will find the house seen at the top of this page (and pictured here in 2013) only slightly modified in the past 120 years. The most noticeable exterior change has been the addition of a second-floor enclosed porch over the entry. Otherwise, this Queen Anne home is largely intact. (Author.)

The Walker Place at 99 South Downing Street is a good example of the 1863 Denver fire-code regulation that all buildings were to be constructed of brick. This image of the farmhouse dates from 1905. (Denver Public Library.)

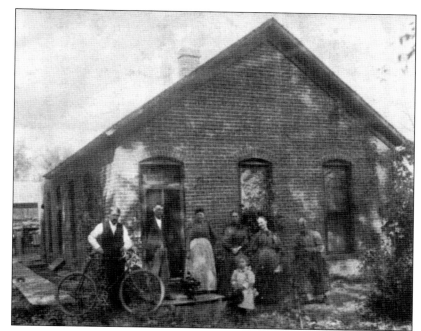

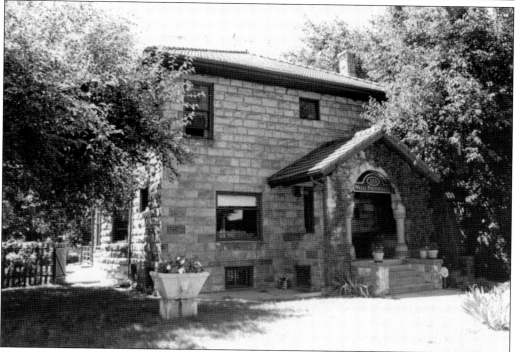

This 19th-century home made of stone serves as a good example of a symmetrical version of the Denver Square, a popular housing style found in Washington Park neighborhoods. Buildings in the Denver Square, or Foursquare, style are two-story structures with a rectangular footprint or plan, topped by hipped roofs and attic dormers. The hipped roof provides second-story height without the massing of the gabled-roof style. (*Washington Park Profile.*)

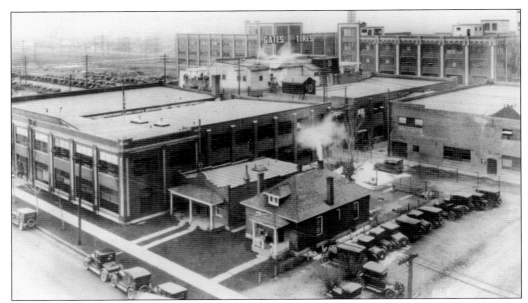

In 1911, Charles and Hazel Gates acquired a mail-order business called the Colorado Tire & Leather Company to support their growing family. The sole product was the Durable Tread, which was composed of elk hide with steel studs and was attached to worn tires to add 5,000 miles of wear. Using leftover elk hide, a horse halter was developed in 1912 as the company's second product and was widely promoted by "Buffalo Bill" Cody. (*Washington Park Profile*.)

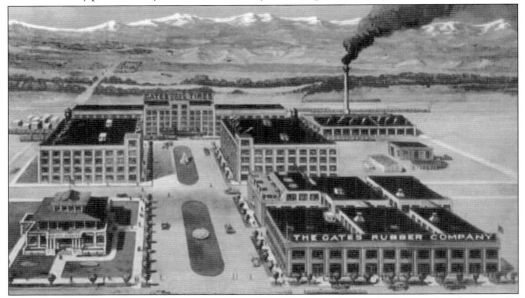

Colorado Tire & Leather Company purchased land at 999 South Broadway in 1917 and eventually changed its name to Gates Rubber Company. Located between the streetcar route to Englewood and the rail lines of the Denver & Rio Grande Railroad and the Colorado and Southern Railway, Gates's innovative model-factory philosophy made it an internationally renowned rubber company. By the 1950s, Gates was Denver's largest manufacturing firm, and many of its 5,500 employees were residents of the neighborhoods of South Denver. (Front Range Research Associates.)

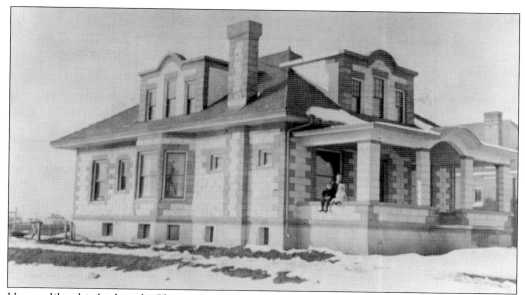

Houses like this high-style Classic Cottage are more common on the west side of Washington Park. Typically, these cottages were one-and-a-half-story, rectangular residences with a floor plan, hipped roof, and ornamentation similar to the Foursquare. High-style Classic Cottage designs are distinguished from traditional cottages by the presence of multiple dormers rather than only one over the front door. Their porches are more likely to span the full front of the house, and porch pillars are more likely to be made of wood than of brick or stone. (*Washington Park Profile.*)

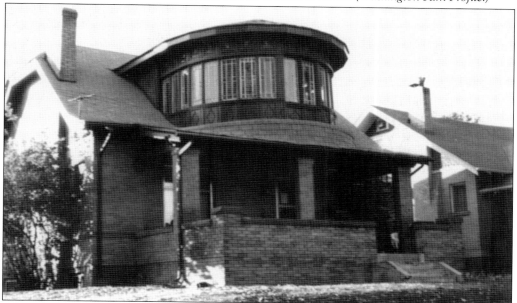

The "Captain's House" in the 1000 block of South Downing Street, with its modified Bungalow style, is among the most unusual houses in the neighborhood. It was built by a sea captain in 1911 overlooking Grasmere Lake in Washington Park. The second-floor front exterior resembles the wheelhouse of a riverboat embellished with stained glass. When lighted in the evening, it glows with warm, colorful light. (*Washington Park Profile.*)

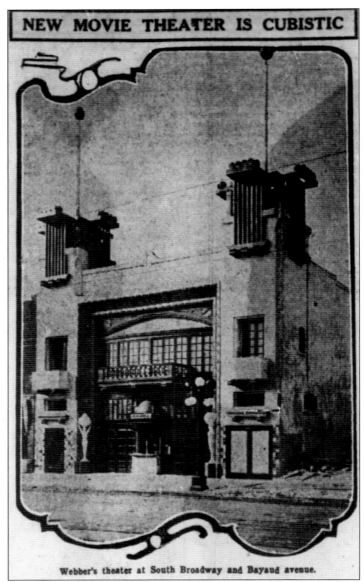

NEW MOVIE THEATER IS CUBISTIC

Webber's theater at South Broadway and Bayaud avenue.

Movie houses in Denver had a banner year in 1916. Most were downtown, but pioneer showman DeWitt C. Webber chose to build his Webber's Show on South Broadway to rival Curtis Street's status as "Movie Row." Webber was a prominent member of the photoplay family and among the first to exhibit films in Denver. An avid South Sider, he served several terms as city attorney for the Town of South Denver. The August 5, 1916, issue of *Moving Picture World* describes Webber's 1,000-seat theater at Bayaud Avenue as cubistic in design and constructed of ornamental stucco. Its convex facade extended three stories and was embellished with French doors and bronze balconies. The interior boasted an aquarium with a background of mermaids painted on turquoise velvet and a water fountain sculpted in the form of a woman's head with water bubbling alluringly from her lips. Webber lived in an apartment on the second level until his death in 1944. (*Washington Park Profile*.)

24

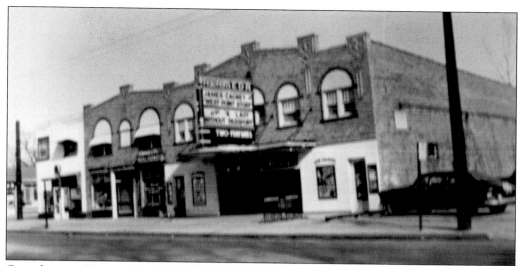

Over the next 50 years, South Broadway movie theaters, along with local neighborhood theaters such as the Alameda at 312 South Pearl Street, rivaled Curtis Street and other downtown theaters. The Alameda Theater opened in 1926 under the name Majestic Theater and served this South Denver neighborhood until it closed in late 1958. (*Washington Park Profile*.)

When the 750-seat Mayan Theatre opened in 1931, it was the new gem of the Miracle Mile along Broadway from Sixth Avenue to Alameda Avenue. Mayan Revival architecture was a popular theme for theaters at the time. Today, the Mayan is only one of three theaters in the country that still feature this iconic style. In the 1980s, a new owner bought the surrounding block and, convinced that the Mayan was a blight on the area, made plans to have it demolished. Neighbors rallied to prevent the loss of yet another Denver landmark. In 1984, a group called the Friends of the Mayan was formed and petitioned the city to have the building designated a local historical landmark—against the owner's wishes. After prolonged negotiations, the status was granted when new owners bought the theater in 1985. (*Washington Park Profile*.)

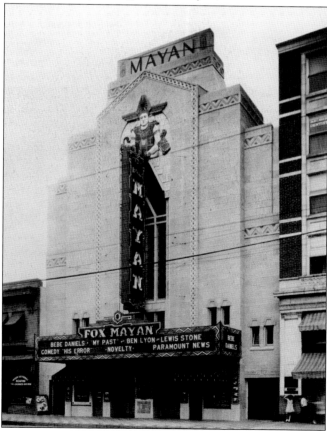

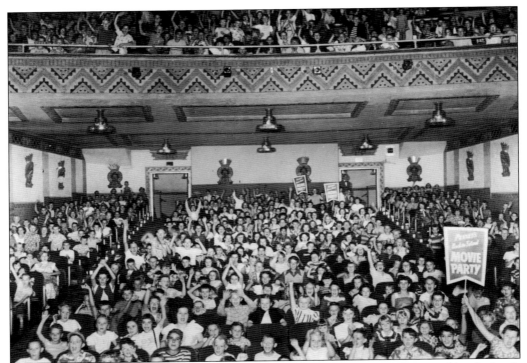

An example of the close connections between the business community, residents, and local schools is commemorated in this image of the celebration of the start of the school year when these lucky students got to see a movie at the Mayan Theatre. (*Washington Park Profile*.)

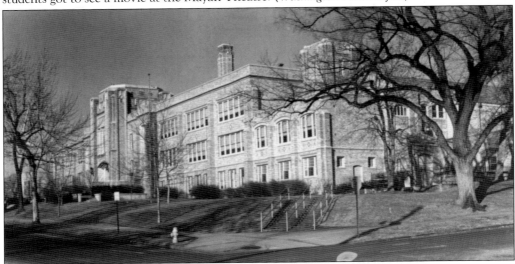

In 1921, Denver Public Schools embarked on a building program that added dozens of school buildings to the district, including Byers Junior High, shown here. The Collegiate Gothic–inspired design was emblematic of the City Beautiful principles, as its site atop a hill east of Broadway boasts views from Longs Peak to Pike's Peak. When built, this school was touted as one of the 40 most beautiful schools in the country. The location was once the homesite of Williams Byers and his family. (*Washington Park Profile*.)

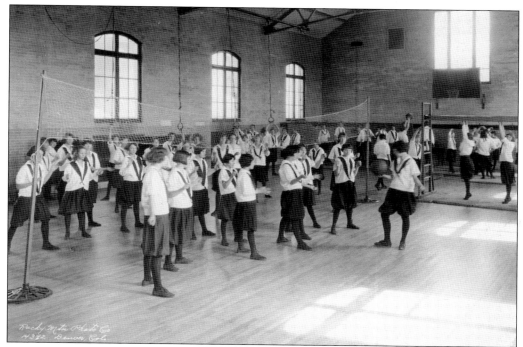

The junior high school boasted two gyms—one for boys and one for girls. Here, the students are practicing their volleyball in the girls' gym. (Denver Public Library.)

This class photograph from the 1930s, taken at the school's main entrance, shows clearly the original front doors with their traceried woodwork and leaded glass. These features are no longer found in modern school buildings but are being preserved in Denver's older schools. (South High Alumni Association.)

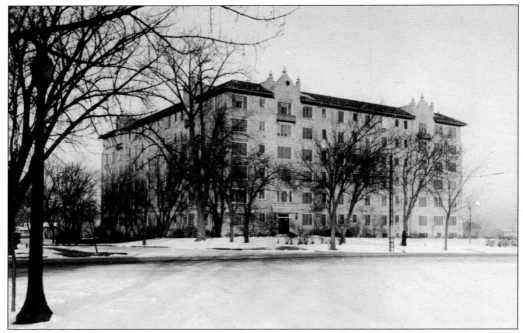

In 1924, on the site of the old Walker Place at 99 South Downing Street, noted local architect William Norman Bowman designed another Denver Landmark, the Norman Apartments. Bowman used an eclectic design reminiscent of the Colonial Revival and Spanish Colonial Revival styles for this building with nine foot ceilings and mahogany doors and trim. It was his home for many years. (Denver Public Library.)

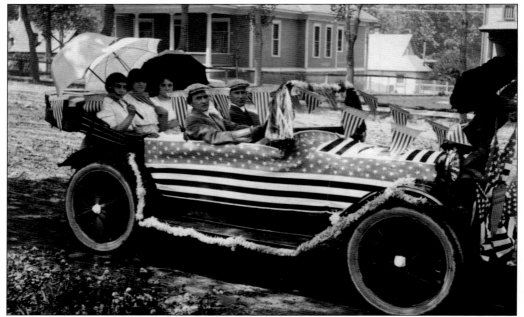

This convertible decked with flags and driving the Marion Street Parkway to Washington Park might have been a common sight near the Norman Apartments. (Charlotte Winzenburg.)

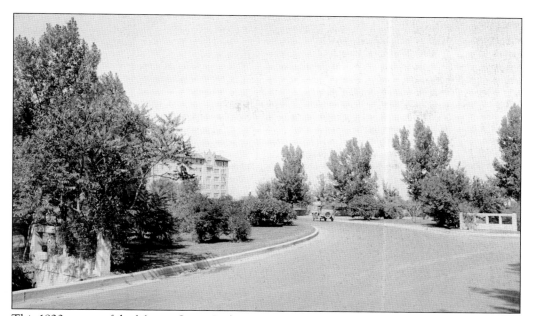

This 1920s scene of the Marion Street Parkway north of Washington Park is an excellent example of the City Beautiful Movement's emphasis on generous landscaping amid broad parkways. City landscape architect S.R. DeBoer is credited with implementing Mayor Speer's vision of connecting parks with parkways and is said to have personally planted 120 crab apple trees here to demonstrate their hardiness and ability to withstand Denver's harsh winters. (Denver Public Library.)

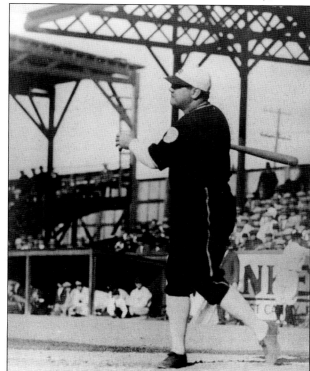

In 1927, Babe Ruth played first base at an exhibition game at Merchants Park on South Broadway, teaming with Denver's semiprofessional team, the Piggly Wigglys; Ruth's uniform was emblazoned with "Bustin' Babes." A handwritten note on the back of the image states that the Piggly Wigglys played against first baseman Lou Gehrig and his Larrupin' Lous, teaming with another semiprofessional team, the Denver Buicks. Note Gehrig is visible in the background (with his back to the camera). (*Washington Park Profile.*)

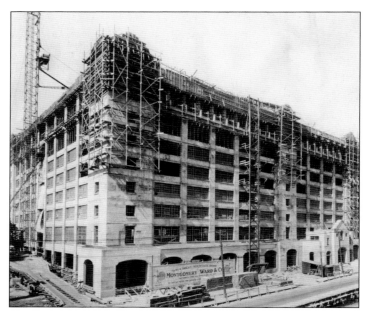

Montgomery Ward & Co. opened in early 1929 and was designed in an adapted Mediterranean style featuring soft-shaded buff concrete with Spanish ornamentation, a red-tile–trimmed roof, and small balconies with ornamental iron railings. This nine-story structure with 727,000 square feet of floor space was made with rough plaster walls and iron chandeliers and was entered through monastery-style doors of wood heavily studded with brass. The store was visited by 50,000 on opening day. (*Washington Park Profile.*)

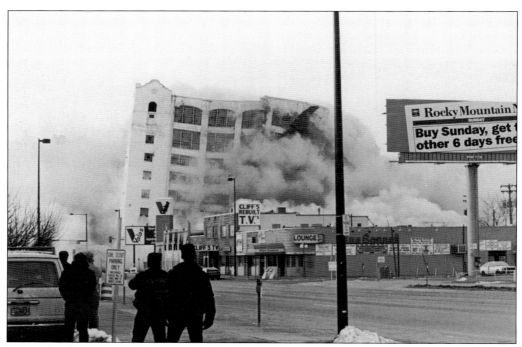

Known by the company as "Denver House," this structure was located adjacent to major railroad lines, which facilitated the business's promise, "In Today—Out Tomorrow." The Denver location was one of those where the company combined retail stores with warehouse space for its predominantly mail-order business. When fully operational, the store employed 1,000 people. It was demolished in 1990 after standing vacant for several years. (*Washington Park Profile.*)

Epiphany Lutheran Church on South Corona Street at Ohio Avenue was built in 1938 after the original church building was lost to bankruptcy during the Depression. Church lore claims Epiphany's stained-glass windows and pews were "boosted" from the original church, Trinity Lutheran (also called Barnitz Memorial Lutheran), on South Logan Street at East Dakota Avenue. One church member crafted Epiphany's metal hanging chandeliers from Model T or Model A fenders. (*Washington Park Profile.*)

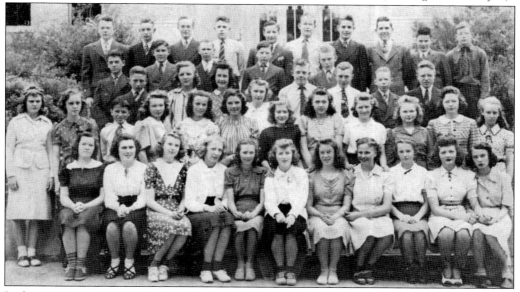

In this 1940 Byers ninth-grade class photograph, Nita Jean Charon stands on the far left in the second row. Growing up on the 400 block of South Logan Street, Nita Jean went to Lincoln Elementary and attended Barnitz Memorial Lutheran with her family. There, she met future husband Leonard Molberg. They both attended South High. For 60 years, Nita Jean served as church organist at Epiphany Lutheran, where she still attends services with her great-grandchildren. (Nita Jean Molberg.)

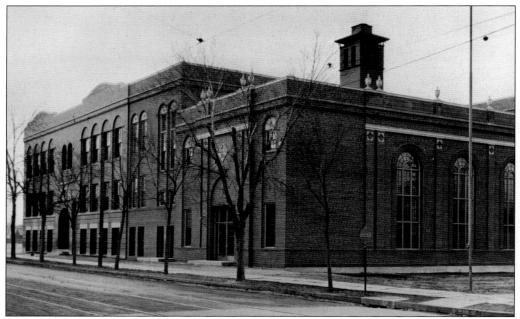

Lincoln Elementary was named a Denver Landmark in the mid-1990s as part of a citywide initiative to designate the city's most architecturally and historically significant schools. Students studied the history of their school and its architectural style. They defended its nomination as a Denver Landmark before the school board, the Denver Landmark Commission, and city council. (Denver Public Schools.)

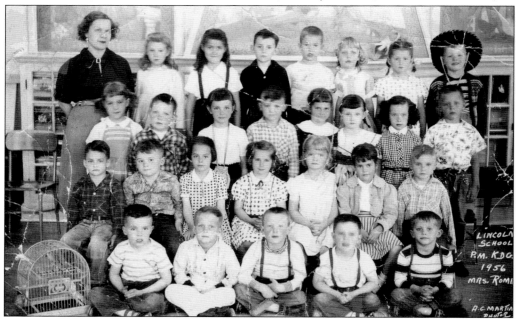

Pictured here is the 1956 kindergarten class at Lincoln Elementary on South Pearl Street. From here, these students would likely matriculate to Byers Junior High, sited a few blocks north, or to Grant Junior High, located about a mile south on South Pearl Street. Many of those pictured here would then attend South High, located at the southern edge of Washington Park. (South High Alumni Association.)

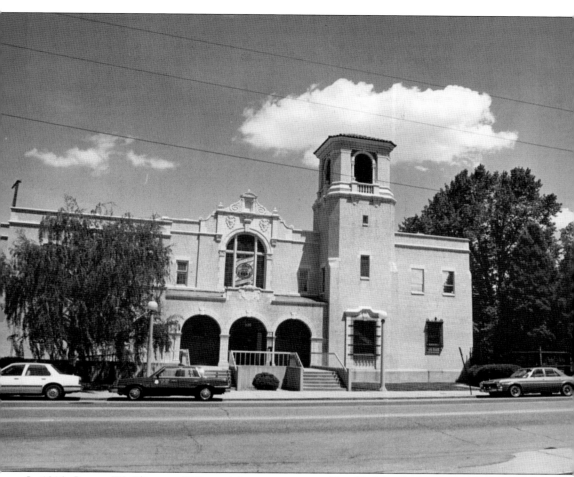

In 1916, George W. Olinger of Olinger Mortuary organized his Highlander Boys as a way to thank the local businessman who befriended him in his youth. Throughout its history (1916–1976), 20,000 boys in metropolitan Denver participated in the "Highlander experience," where they were trained to show respect, commitment, courtesy, and loyalty. The Temple of Youth, shown here, was built by the Highlander Boys Foundation in 1930 at 300 Logan Street. It was dedicated with the help of renowned composer and bandleader John Philip Sousa. Unfortunately, the Depression took its toll on foundation fundraising and the building had to be sold in 1933. Until its demolition in 1999, the property was commonly known as the National Guard Armory. The site is now home to television station KUSA, Channel 9. (*Washington Park Profile.*)

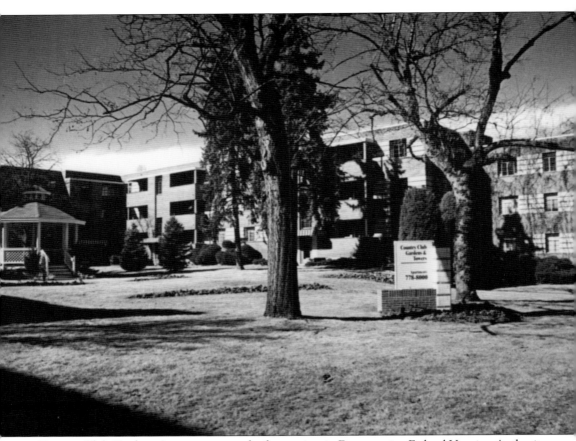

Country Club Gardens Apartments was the first project in Denver using Federal Housing Authority loans to build a multiunit complex. This Denver Landmark, built in 1940, was designed by noted architects Fisher, Fisher & Hubbell in the International and Moderne styles. The Moderne elements are demonstrated by the horizontal bandings that follow the window lines around corners contrasting with the brick facade. Developers hoped to attract middle-class renters to this spaciously landscaped garden complex along the historic Downing Street Parkway, designed by renowned master landscape architect M. Walter Pesman. (*Washington Park Profile.*)

Two

MYRTLE HILL

Myrtle Hill was settled by several families, including the Baileys, the Bohms, and the Lorts. Carrie Bartels Bailey, a promoter of land sales, gave the Myrtle Hill area its name in 1888. This is also the name given to the neighborhood's first school, which was built on land donated by Bailey on South Race Street at Tennessee Avenue. In early Colorado, schools were often built to increase an area's attractiveness for homebuilding and settlement. On more land donated by Bailey and her husband, Frank, in 1893 at Tennessee Avenue and South High Street, a church was constructed. In 1912, the church name was changed to Washington Park Community Church.

According to noted Denver historian Phil Goodstein, George Bohm platted land to the east of what would become Washington Park in 1872, eventually building a high-style Classic Cottage house that stood for more than 100 years at 900 South Franklin Street. Bohm is credited with bringing streetcar service to the east side of Washington Park. The Lorts were another active Myrtle Hill family. Frank, a paperhanger and painter, came first in 1891. He enticed his sisters to join him in Denver, and their home became the neighborhood gathering place. In 1894, the sisters opened a private kindergarten, and later, a Sunday school in their home on South High Street. A nephew, Joseph, eventually served as principal of South High School from 1950 to 1960.

In 1893, the Lorts and Baileys are credited with starting the church that became Washington Park Community Church. The church building is now a Denver Landmark, and over the past 100 years, it has served as the site of hundreds of community meetings. Farmhouses and bungalows soon coalesced into the makings of a neighborhood. The first streetcar route into what is now East Washington Park established an increasingly popular shopping district on a single block of South Gaylord Street. Looking behind many of the storefronts, one can see vestiges of the original houses. This one block along South Gaylord Street is well known throughout Denver as a great place to wander, shop, and eat.

The school district received a court order to institute busing to achieve racial desegregation in its schools during the mid-1970s. Many families in predominantly white neighborhoods took their children out of the neighborhood public school, including those in Washington Park. Citywide, the school population dropped by one-third as a result, and many of the school buildings constructed in the 1920s and 1950s were virtually empty. Consequently, the school district closed, sold, and demolished almost two dozen historic buildings. Washington Park was affected by these events.

A neighborhood resurgence began in the late 1980s as young families rediscovered Washington Park. School enrollments rose to capacity, with the neighborhood and its attractions once again becoming popular in Denver.

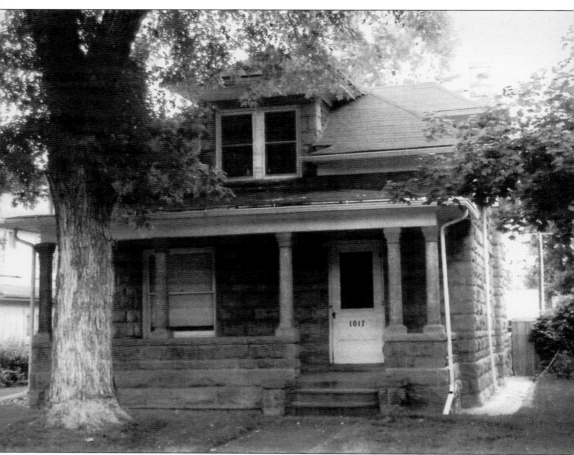

A water-tap application was submitted by Charles M. Clayton, a stonecutter, in 1894. It is believed that Clayton both designed and built this house at 1017 South Race Street. It is perhaps the most distinctive stone house in the Washington Park area once known as Myrtle Hill. The builder used three types of Colorado stone—Lyons sandstone, rhyolite tuff, and Manitou sandstone—laid in a pattern forming stripes and squares based on the color of the stones. It is highly unusual for a modest house to have this variety of stone. Even the front porch and supporting pillars are stone. This residence is one of the earliest remaining examples of houses built east of Washington Park. Although unique in design, it most reflects a Classic Revival Cottage style with its rectangular floor plan, hipped roof, and multiple dormers. When it was built, the original Myrtle Hill School was next door. The house is now a Denver Landmark. (Neahr Landmark Nomination.)

The Neahr family purchased the house in 1919 and lived there for 80 years. Husband and father Will Charles Neahr held several electrical patents for his inventions. He married his wife, Rose, in 1911, and she lived at the home until her death in 1975. Their son Will George Neahr, a certified professional engineer, is credited with engineering the heating on the Eisenhower-Johnson Memorial Tunnels along Interstate 70. After retirement, he restored antique clocks as a hobby. He lived nearly all his life in the house and died in 2002. (Neahr Landmark Nomination.)

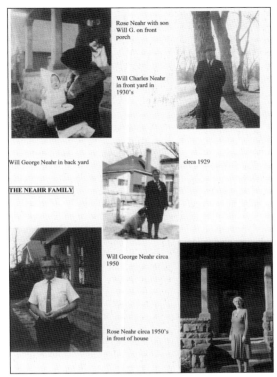

THE NEAHR FAMILY

Rose Neahr with son Will G. on front porch

Will Charles Neahr in front yard in 1930's

Will George Neahr in back yard

circa 1929

Will George Neahr circa 1950

Rose Neahr circa 1950's in front of house

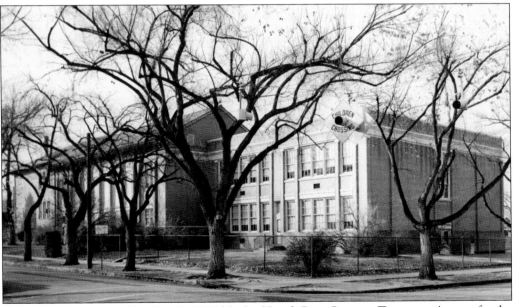

Carrie E. Bailey donated land in the 1000 block of South Race Street at Tennessee Avenue for the original two-room Myrtle Hill School in 1893. Pictured here is the 1906 Myrtle Hill School, built with no electricity or sewer facilities, with subsequent 1922 and 1928 additions. The 1922 addition upgraded the school's facilities, and the name was changed to Washington Park School. The school served neighborhood children until it closed in 1982. (Denver Public Schools.)

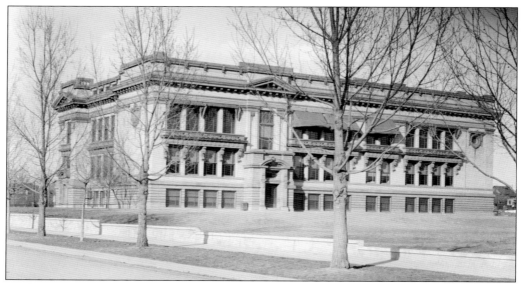

Steele Elementary began its 100-year history along Marion Street Parkway on spacious grounds. It was designed by David Dryden in 1913 in the Beaux-Arts architectural style and is an enduring example of several features important in the City Beautiful Movement. A longtime neighborhood asset, the grounds were the tent site for the Washington Park Community Church in 1915 while members were waiting for their church to be built on South Race Street. (Denver Public Library.)

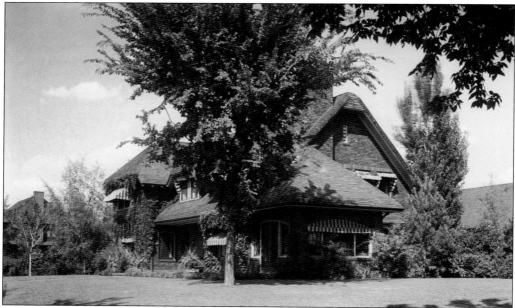

Overlooking the eastern edge of Washington Park stands one of the more distinctive local residences. The Causey House, with its undulating roofline, was designed by the firm of Marean & Norton in 1913 and was a few lots south of Marean's own home, built five years earlier. Historic Denver, Inc., published an informative Washington Park walking-tour guide, written by Nancy Widmann, that includes this and other architecturally significant neighborhood houses. (Denver Public Library.)

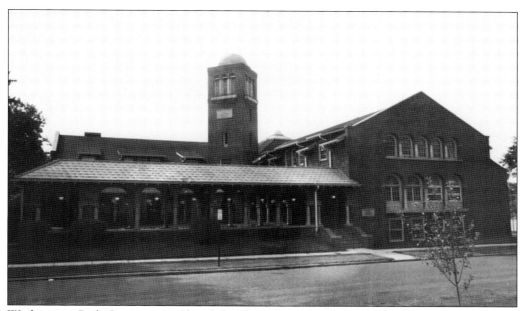

Washington Park Community Church has been a centerpiece of the Myrtle Hill community since 1893. Designed by neighbor Willis Marean and his firm of Marean & Norton in an Italian Revival style, the church has stood at the corner of Arizona Avenue and South Race Street since 1917. Its sanctuary is embellished with ivory and mahogany. (*Washington Park Profile.*)

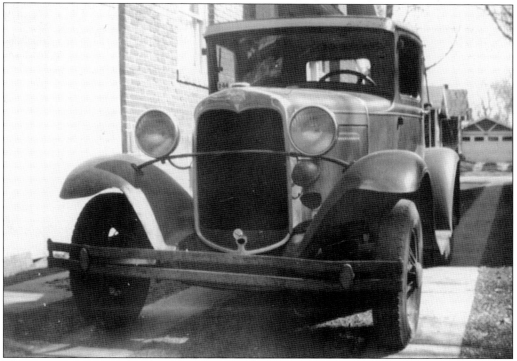

Horsecars were replaced with cable cars and trolleys, which in turn were eventually replaced with cars like this Model A that once rode on South Denver streets. (Bushman family.)

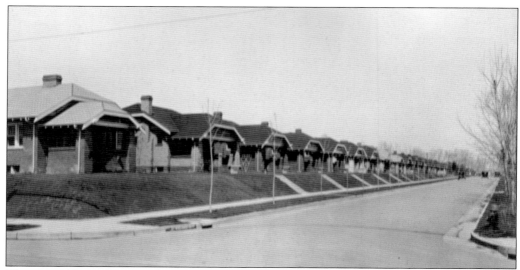

This row of bungalows was built on South Williams Street at East Kentucky Avenue in 1925. The houses sit on their lots facing east and west to take the greatest advantage of solar access. The wide eaves of both Cottage- and Bungalow-style houses block the hot summer sun, keeping interiors naturally cool, yet allowing the winter sun's rays to flood the living spaces with warmth and light. (*Washington Park Profile*.)

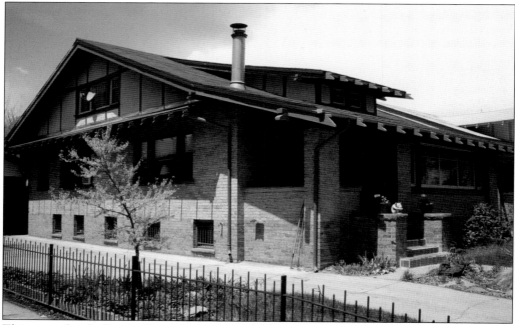

This example of a Denver Bungalow, a favorite home style between 1910 and 1930, boasts low-pitched gabled roofs with exposed rafters and beams as well as wide front porches. Unlike those on cottages, Bungalow porch roofs are part of the main roof, which runs perpendicular to the street. It is said that the simplicity of this functional housing style liberated women from housework, allowing them time to become progressive-era crusaders for causes such as the suffragette movement. (Steele Elementary School.)

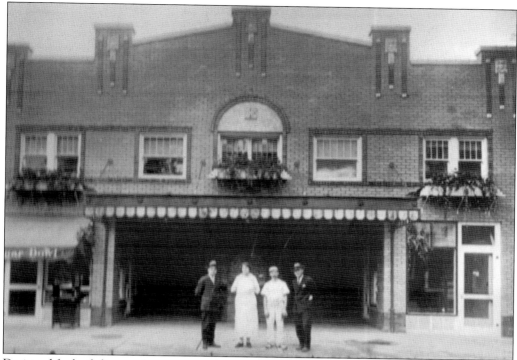

Designed for both live performances and movies, the Washington Park D&R Theater celebrated its opening on South Gaylord Street in 1925 by giving away Shetland ponies. Now preserved, it is home to various neighborhood-based shops. (*Washington Park Profile.*)

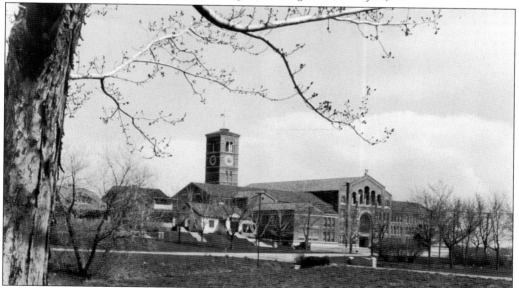

This view of South High School and bordering houses from Washington Park is much the same today as it was in the days before area roads were paved. The white bridge visible in the foreground is one of many crossing Smith's Ditch as it meanders through Washington Park; these were built as part of the Works Progress Administration program in the 1930s. (South High Alumni Association.)

Over the past 85 years, South High students walking to school on snowy days have been glad for this side entrance to the monumental building that takes up a full block at the southern edge of Washington Park. (South High Alumni Association.)

The members of this baseball team from the 1930s proudly wear their shirts emblazoned with "South Gaylord Merchants." Much like the South Broadway merchant and civic associations, the South Gaylord Merchants Association has long supported the community. During the 1950s and 1960s, the association, together with the Bonnie Brae merchants along University Boulevard (formerly called East Broadway), were invaluable and stable influences that kept the area vibrant. (*Washington Park Profile.*)

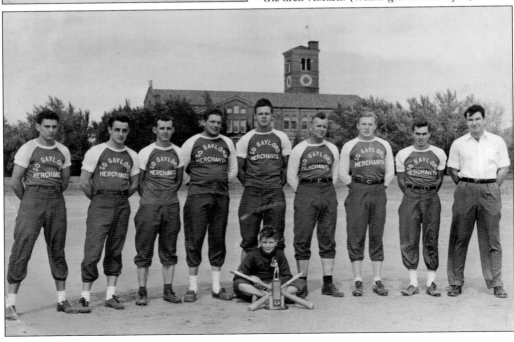

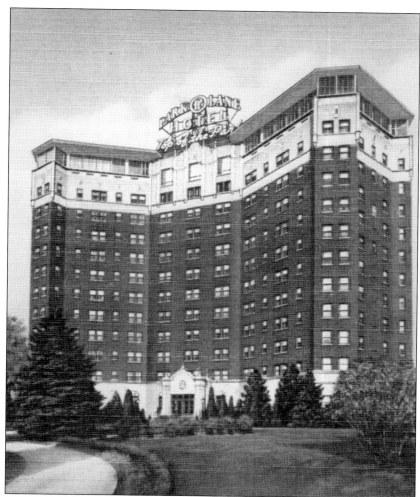

To take advantage of the popularity of Washington Park, in 1928, Paul Stein, an architect/developer/hotel manager from Chicago, built the Park Lane Hotel. The "Friendliest Hotel in the West" opened with 225 rooms, including 134 apartments, and was situated along Marion Street Parkway on one full block immediately north of Washington Park. At one time, the hotel boasted a swimming pool, tennis courts, and a pair of nine-hole putting greens. Between 1939 and 1965, the hotel suffered multiple bankruptcies; it was sold, taken back, and sold again repeatedly. Despite the financial difficulties, during the 1950s, it was a "destination hot spot," with dance and jazz bands playing on a roof garden for dancing under the stars. In 1949, the radio station KTLN began broadcasting from a glass booth on the ground floor, and the Top of the Park opened. Sunday brunch served here is still remembered fondly as a special treat. It also served as home to Denver's first television station, Channel 2, beginning in 1952. Limousine service and a scattering of cottages throughout the grounds attracted some of Denver's social elite to the Park Lane home; among them were a US senator, a financier, former Denver mayor Henry J. Arnold (1912–1913), and "Tea for Two" composer Vincent Youmans. A popular American theatrical composer and Broadway producer, Youmans got the theater bug when he produced troop shows for the Navy during World War I. In 1966, the hotel was sold to local Denverites who allowed the fire department to set fires in it for training purposes before they tore it down. The site now has four 20-story condominium towers that were built in the 1970s. (Genealogybug.net.)

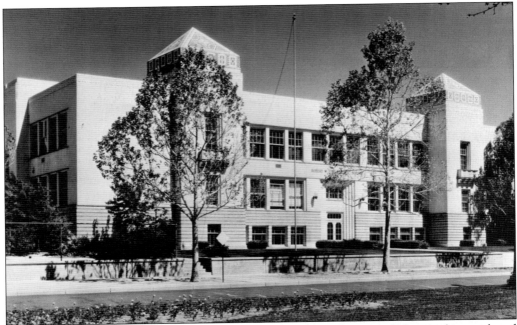

In 1929, when an addition was built onto Steele Elementary School, Hoyt and Hoyt Architects altered the facade in an Art Deco style. Twin towers are embellished with colorful mosaic tiles, indicative of the school's monumental status and again emulating City Beautiful Movement principles. With the 1929 addition, the front entrance was shifted to face Marion Street Parkway, giving the school an even greater presence. Both the school and the parkway are Denver Landmarks. (Denver Public Schools.)

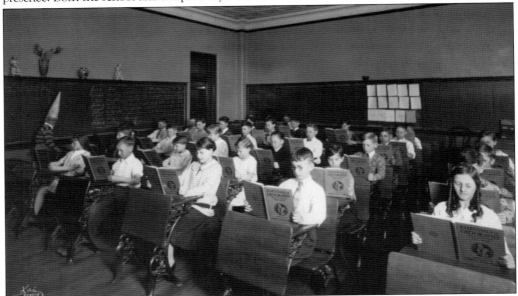

Though some might wonder if the wearing of a dunce cap is a myth, this Steele classroom of 1934 shows there may be some truth to the stories. Note the student on the left, isolated and wearing a dunce cap. One might assume that the rest of the class is only pretending to read *Essentials of Geography*. (Steele Elementary.)

City Beautiful principles were practiced inside and out in Denver's public buildings, including schools. Seen here is one of two decorative metal vents found in the elementary school library. Steele Elementary, like many Denver Public Schools institutions built prior to World War II, contains many elaborate embellishments, such as fireplaces, murals, and decorative light fixtures. (Author.)

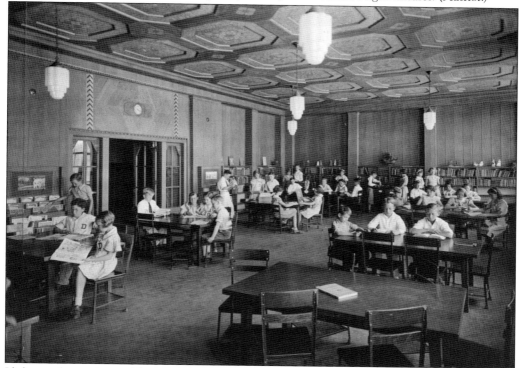

If the students pictured here in 1934 were to visit Steele Elementary today, they would find many of the library's original artistic and architectural features still in place. The ceiling painted in geometric designs invokes an Art Deco theme and remains intact. The wood paneling also remains, as do some of the original bookcases and stands. The light fixtures have been changed, but the students can reportedly find some of those pictured now hanging in the auditorium. (Steele Elementary School.)

Like the pioneer settlers who established their homes on the west side of what is now Washington Park, people who built homes on the east side of Smith's Lake raised their families and passed along their property to children and grandchildren. Pictured here is the home of one such family that has lived on South Gaylord Street since the 1940s. (Bushman family.)

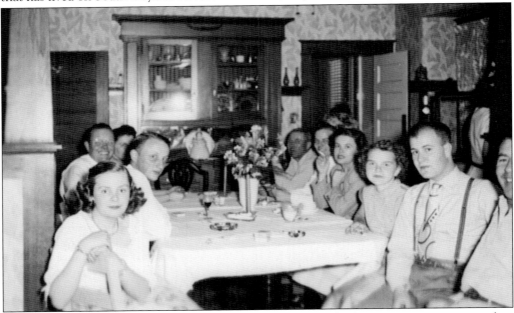

At holiday time, the dining room table would extend into the living room to accommodate everyone. Here is one such gathering around 1945. Note the built-in oak breakfront and wide doorway trim. Many houses in the Washington Park neighborhoods maintain this type of original Craftsman detailing. (Bushman family.)

Cousin Dorothy Smith poses in front of the ceramic-tiled fireplace surrounded by built-in oak bookcases and flanked by multilight casement windows that were popular interior embellishments in Craftsman-style bungalows. (Bushman family.)

Shown here at age 2, this South Gaylord Street resident is being held by his grandfather outside what is now his family's home. Like many in the Washington Park neighborhoods, the toddler's own children remember no other home and have memories of walking to their neighborhood school when the snow was waist-high. (Bushman family.)

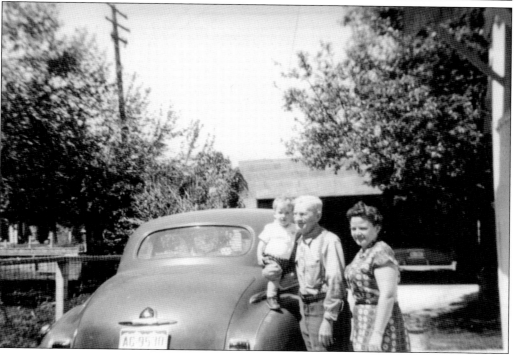

Elitch's Amusement Park has been a main attraction for people from all over Denver for 120 years. These three friends from South Denver memorialized their day at the amusement park around 1941 with this group photograph from Elitch's picture booth. (South High Alumni Association.)

South High students pose on South Gaylord Street in 1944, the closest popular hangout to campus. (South High Alumni Association.)

South High's yearbook was called the *Aeronaut*, but one 1938 graduate, budding and published author Bert Stiles, went on to become an actual aeronaut as a famous bomber and fighter pilot in World War II. (Colorado College Special Collections, Bert Stiles Papers.)

Having completed 35 missions as a B-17 copilot, Stiles (first row, second from right) opted to remain in Europe as a fighter pilot. He was killed in a crash on his 16th mission after shooting down a German FW-190 fighter. Published posthumously, his book about the experience of flying bombers, *Serenade to the Big Bird*, is a classic of flying literature. (Colorado College Special Collections, Bert Stiles Papers.)

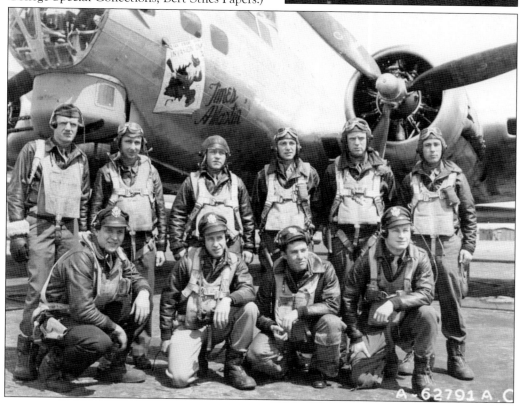

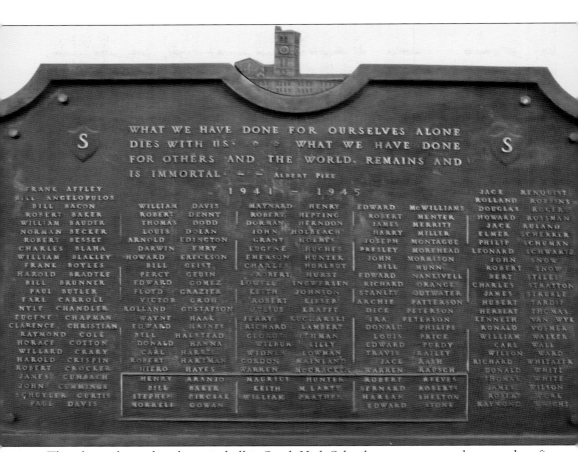

This plaque, located in the main hall in South High School, commemorates the more than five dozen students and alumni who gave their lives in the service of their country from 1941–1945. (Jerry McCarthy.)

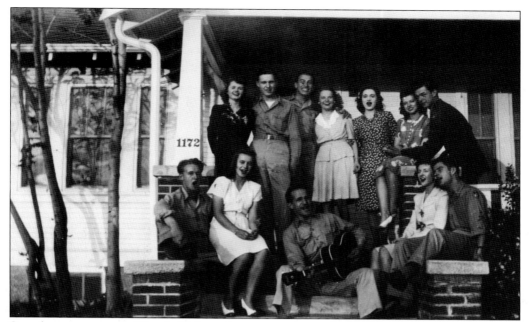

Seen here is a group of South High students singing on a South Denver front porch in 1944. Music has long been an important feature in this community; yearbooks from the 1920s feature boys' and girls' glee clubs at South Side High. (South High Alumni Association.)

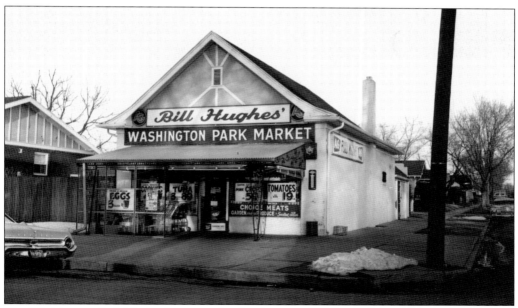

The Washington Park Market began in this farmhouse at 598 South Gilpin when milk and bread were sold from the front room. Bill Hughes began working there, and in 1940, he purchased the business. He called approximately 80 percent of his customers by name. Initially, orders were phoned in for same-day delivery, but in early 1944, self-service was offered, although home delivery continued until the business was sold. (Bob Hughes family.)

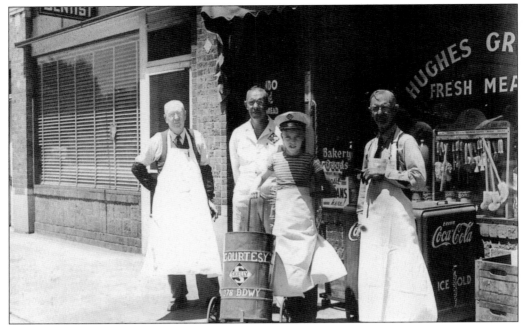

In its early years, South Denver had many neighborhood grocers. One along Broadway and near Fourth Avenue was the Hughes Grocery run by William Hughes Sr. The young boy in the cap was captured making a delivery for the Skelley gas station located around the corner. (Bob Hughes family.)

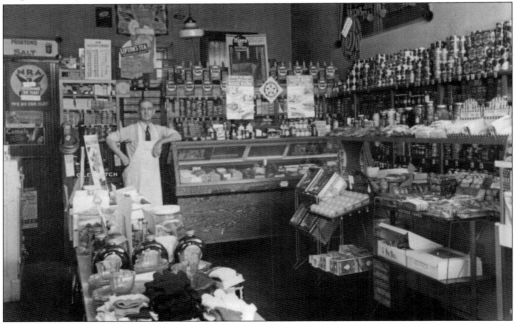

Note the canned goods stacked high at the Hughes Grocery. Some brands, such as Lipton's tea and Hostess cakes, have lasted through the decades. Hires Root Beer was available from William Hughes Sr., shown leaning on the deli counter. (Bob Hughes family.)

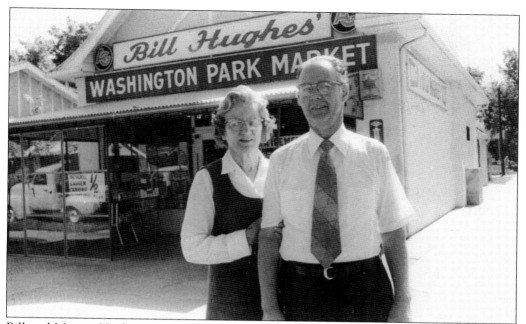

Bill and Mayme Hughes, pictured here, were boosters of South Denver Merchants and lived nearby. Bill was quoted saying he "makes it there and spends it there." Because the market was in a residential area, it was never able to expand one inch. Despite being cramped, this business was innovative. It had Denver's first charge cash register and was the first grocery in South Denver with fluorescent lights. (Bob Hughes family.)

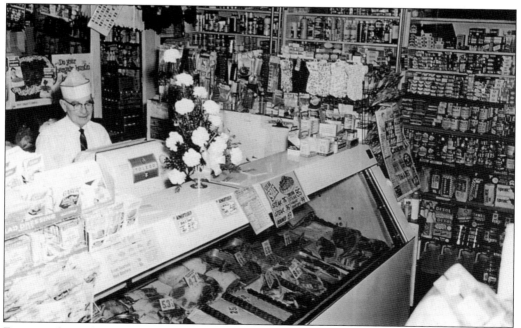

For more than 25 years, Clyde Van Gilder was one of the market's butchers and a loyal employee. Van Gilder was known for his meat-cutting skills and good humor. (Bob Hughes family.)

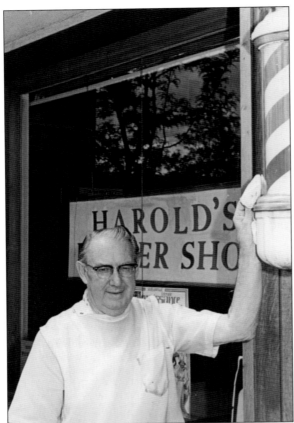

Longtime South Gaylord Street businesses included Harold's Barber Shop and Belmont Plumbing, which had an almost-100-year presence in the area. These and other small businesses played a critical role in building and stabilizing a sense of belonging among residents. Buying local has long generated community benefits beyond the more visible economic value spoken of today. (*Washington Park Profile*.)

Old South Gaylord Street Festivals over the Memorial Day weekend and at Halloween are two current-day events organized annually by the merchant association to gather neighbors and attract thousands of visitors to South Denver and Washington Park. (*Washington Park Profile*.)

Three

CITY BEAUTIFUL

In 1893, Robert W. Speer, who would be mayor of Denver for 10 years early in the 20th century, attended the Chicago World's Fair that presented the first large-scale elaboration of the principles of the City Beautiful Movement. The White City was a tangible representation of urban-planning concepts in the late 19th century—it featured Beaux-Arts monuments with neoclassical features, a transportation system, and no visible poverty. This display is credited with the adoption among various cities of this beautification movement, which was hoped to promote not only beauty but also moral and civic virtue among urban residents. Denver joined this movement in 1904 under Mayor Speer.

Denver's effort had a three-pronged plan: a civic center; parks and parkways, and mountain parks. The intent was to enhance public buildings and spaces with parks and vistas. Of the movement, noted local historian Tom Noel states, "It was the marriage of art and architecture: combining sculpture, painting, artistic detail, and landscaping with first-rate architecture [that] still distinguishes the era."

Mayor Speer encouraged public and private support for the City Beautiful effort and initiated a "Give While You Live" campaign for Denver's wealthy to commission statuary to be placed in parks and other public spaces. Two sculptures sited in Washington Park were given under the auspices of the City Beautiful Movement. One of Mayor Speer's first orders was to have removed all Keep Off The Grass signs, because he believed open spaces and recreational opportunities for urban dwellers were vital to enhancing the quality of life. Mayor Speer added playgrounds, tennis courts, horseshoe pits, and playing fields to local parks' amenities. Today, thousands enjoy the Great Meadow in Washington Park, playing soccer or volleyball or enjoying many other outdoor pursuits on a daily basis (or at least when the sun shines).

Marion Street Parkway beautifies the original Smith's Ditch (a historic landmark) as it leads from Speer Boulevard (another historic landmark) to the Dos Chappell Bathhouse in Washington Park (still another historic landmark). Along the parkway are hundreds of trees and shrubs planted within expansive tree lawns. A lasting legacy of the City Beautiful Movement is the preservation of public schools that have been built along parks and parkways in concert with City Beautiful concepts. Steele Elementary, sited along Marion Street Parkway, was initially designed in the Beaux-Arts style made popular by the 1893 Chicago World's Fair. Allan True murals grace the kindergarten's walls, surrounding the fireplace designed in the hopes that children would feel more at home. South High School, built along the southern boundary of Washington Park in a monumental fashion, boasts the Lombardy architectural style richly embellished with terra-cotta, griffins, gargoyles, and statuary in the senior hall and library. These excellent examples of the City Beautiful Movement show its impact and influence continuing into the 21st century.

This view shows only a small portion of the 25-mile-long Smith's Ditch, which begins at the South Platte River and meanders through what is now Washington Park. Water from the ditch formed a small lake, believed to have originally been a buffalo wallow. This lake became a catalyst for a park in South Denver. (Denver Public Library.)

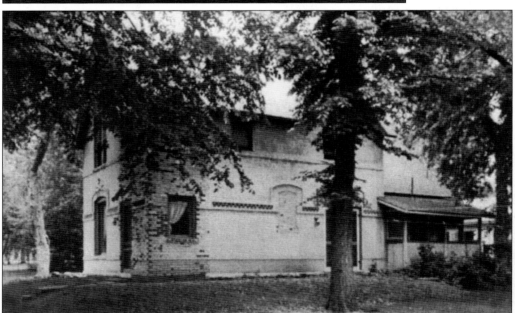

In the fall of 1891, the Town of South Denver acquired 20 acres of the Whitehead brothers' farm as a first step in creating a central park for the community. The City of Denver took on this goal and, in 1898, asked its landscape architect, Reinhardt Schutze, to design a park from the lake to the farmhouse, even though purchase of Smith Lake would not be finalized until 1910. (Denver Public Library.)

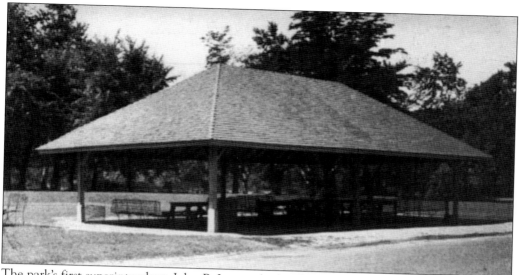

The park's first superintendent, John B. Lang, who lived in the Whitehead Farmhouse, worked closely with the city's landscape architect to create park features. He traveled to the mountains in horse-drawn wagons to gather evergreens, chokecherry, and other shrubs. One of the park's early structures was this open-air pavilion. (Denver Public Library.)

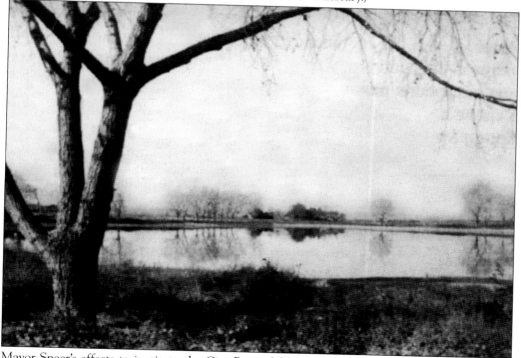

Mayor Speer's efforts to institute the City Beautiful Movement coincided with South Denver residents' efforts to obtain a park. A signature feature of the movement was enhanced vistas from parks and along parkways. The value of this principle can be seen in this c. 1897 mountain view taken from the east side of Smith Lake. Fortunately for current park users, local residents protected this view via a late-20th-century city ordinance. (Denver Public Library.)

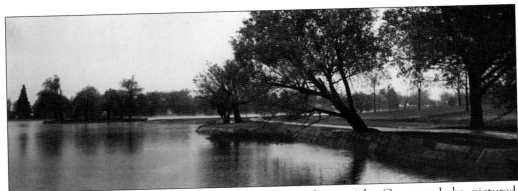

On a High Plains desert, a second body of water is a welcome sight. Grasmere Lake, pictured, was dug in 1906 in the southern portion of Washington Park and is here surrounded by willow trees. (*Washington Park Profile.*)

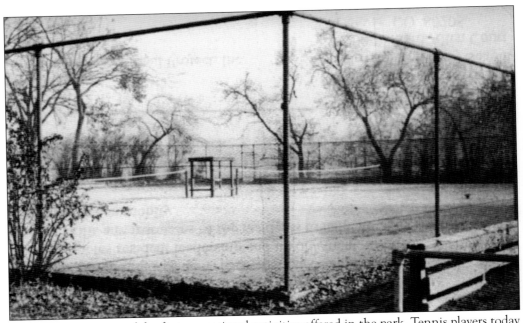

Lawn tennis was one of the first recreational activities offered in the park. Tennis players today have nine courts to use within the park boundaries, and the game has remained one of the most consistent park uses for more than 100 years. Denver records from 1909 document that sports activities in the Great Meadow include croquet and quoits (a game similar to horseshoes). (Denver Public Library.)

At the crest of the hill on the western edge of the Great Meadow, where the Big Ditch flows under the main road, a visitor to the park can take in this view of the flower garden planted by S.R. DeBoer, Denver's second landscape architect. The view today remains bracketed by the trees as seen in this image from around 1910. (Denver Public Library.)

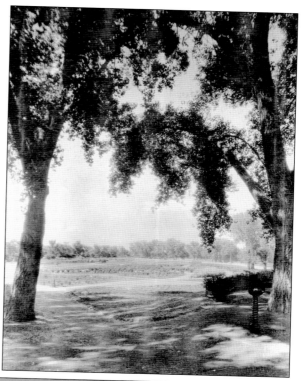

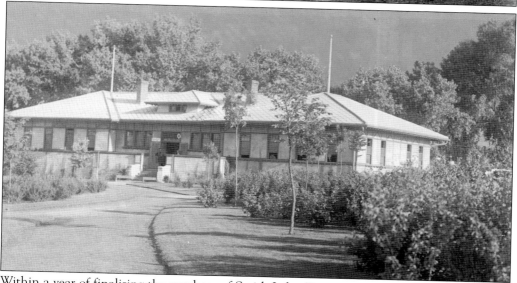

Within a year of finalizing the purchase of Smith Lake, Denver opened its first bathing beach and a new bathhouse in 1911. The waiting room has a fireplace at each end for use in winter as a warming hut for ice-skaters. Important principles of the City Beautiful Movement included public open space and recreational amenities. City engineer Frederick W. Ameter and architect James B. Hyder are credited with designing the 1911 Washington Park Bathhouse. Ameter further added to Denver's City Beautiful Movement with his designs for Montview Boulevard and Richthofen Parkway. (Denver Public Library.)

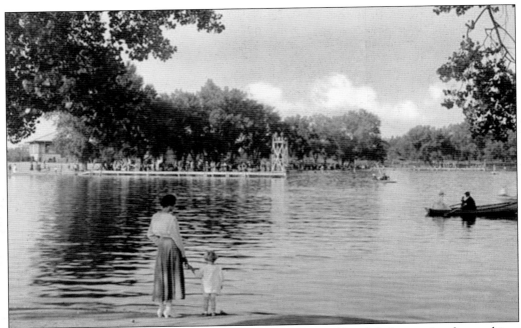

For 100 years, mothers have taken their toddlers to the shores of Smith Lake to enjoy the sunshine, cool breezes, and the antics of the wildlife. (*Denver Municipal Facts.*)

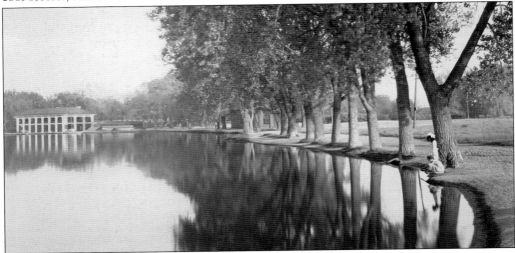

Jules Jacques Benedict, a noted local architect and one of Denver's more flamboyant characters, designed the Washington Park Boating Pavilion, built in 1913 on the southern edge of Smith's Lake opposite the bathhouse. Benedict designed many landmarks, including several houses in South Denver that overlooked the Denver Country Club north of Alameda Avenue. Like many Denver buildings, Washington Park's Boating Pavilion contains a mix of architectural styles. Benedict's unique design incorporates elements of Prairie, Italianate, and Arts and Crafts styles. The exterior of the two-story structure is embellished with multicolored terra-cotta medallions. Lakeside doors on the lower level allowed access for boat storage on straw-covered floors, while the upper level is an open pavilion suitable for large gatherings. Today, people stand in line to secure a permit to use this space for their weddings and other celebrations. (*Denver Municipal Facts.*)

Washington Park offered many new adventures to young women around 1915; wearing "skimpy" new bathing suits and learning to dive were just two of the possibilities. The swimming lake first opened only for men when their locker-room wing was completed in 1911. The women's wing opened in 1912, with its showers and lockers available year-round as most homes did not yet have these accommodations. (*Denver Municipal Facts.*)

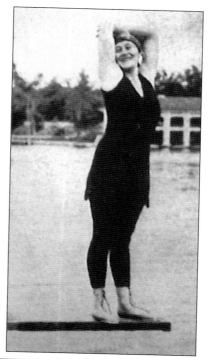

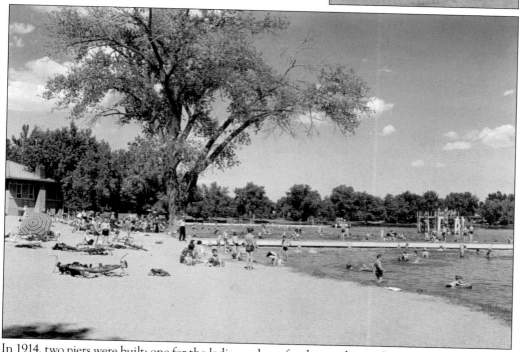

In 1914, two piers were built: one for the ladies and one for the gentlemen. In 1912, a rope laid down the center of the beach divided the women's swimming area from the men's, creating challenges for families trying to enjoy swimming here. Segregation was not limited just to gender. Sadly, for most of its history, Washington Park's beach was for whites only. (Denver Public Library.)

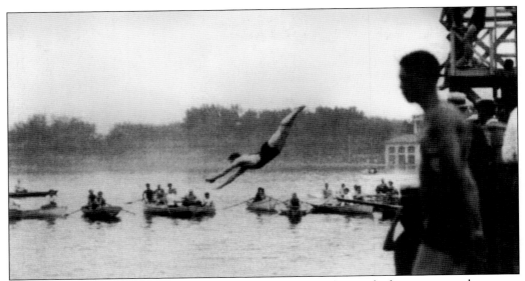

In the 1930s, a third pier was built that included a 10-meter diving platform on a wooden tower. The bathhouse and swimming beach were popular until the mid-1950s, when the facilities were closed due to the polio scare and the high cost of weekly chlorination of the lake. (Denver Public Library.)

The Treat family had a fun day at the beach in August 1918, swimming in the lake and relaxing on the front lawn of the bathhouse. Families could plan to stay all day at the beach because a concession stand offering drinks and snacks was housed on the lower level of the bathhouse. Evidence of these snacks was left on shelves in the concession area until a renovation was undertaken in the mid-1990s. (*Washington Park Profile.*)

S.R. DeBoer was instrumental to Denver's City Beautiful Movement. He served as Denver's landscape architect starting in 1910 and then became Denver's first city planner in 1920s. DeBoer implemented the visionary ideals of Mayor Speer but also attended to the details. He paid particular interest to Washington Park, where he is said to have reset trees and roadway stakes to achieve gentle, flowing lines. (*Denver Municipal Facts.*)

DeBoer liked to plant. On Downing/Marion Street Parkway, he planted a half mile of crab apple trees to prove their hardiness over cherry trees. These still blossom in the spring almost 100 years later. (Denver Public Library.)

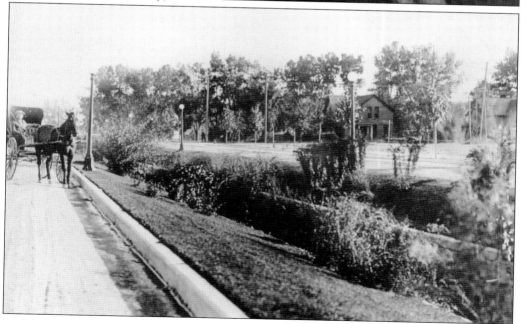

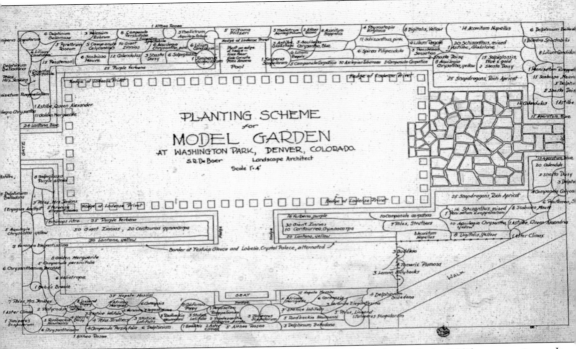

Denver Municipal Facts printed S.R. DeBoer's model garden design in its 1926 summer issue. Its classical lines are readily evident today in Washington Park's Mount Vernon Gardens, designed around that same time, and in the other flower gardens in the park. In 1925, the women living near Washington Park formed a garden club to work with park superintendents to enhance the beauty of the area. Club members donated benches and trees to Mount Vernon Gardens. Waning membership caused the club to disband in 1987. (Denver Municipal Facts.)

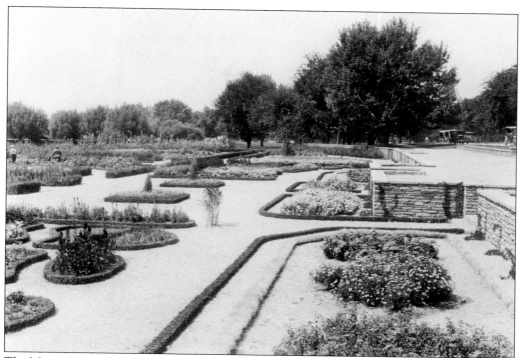

The Mount Vernon Gardens are based on designs from George and Martha Washington's home in Virginia. An oak sapling from Washington's Virginia plantation was planted nearby by Adam Kohankee, the park's second superintendent. (Denver Public Library.)

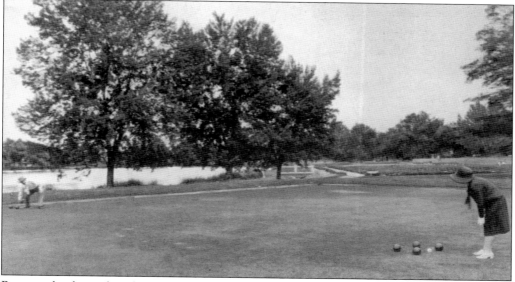

Bocce, or boules, is thought to have originated in Egypt as early as 4000 BC. The Washington Park Lawn Bowling Club helped create a regulation-sized green in 1924 on the northeastern shore of Grasmere Lake. In 1925, the club built its clubhouse nearby, complete with window box. This image dates from 1927, when the club had three greens to maintain. Today, the club members maintain one green, which is used for competitions beginning each year in April. (*Denver Municipal Facts.*)

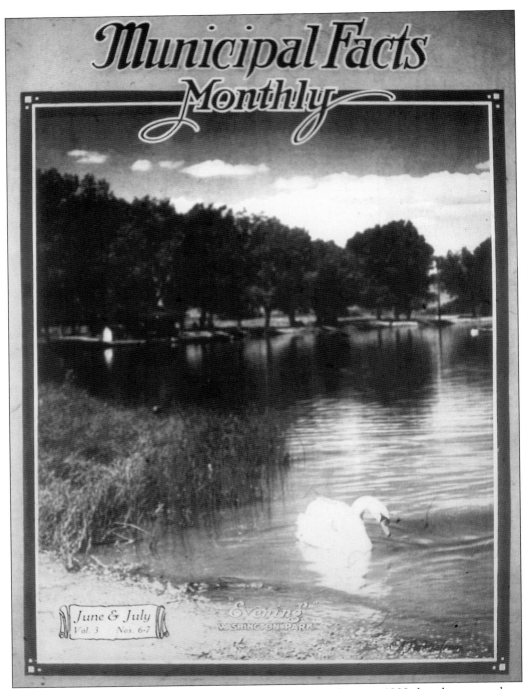

Denver Municipal Facts was a publication initiated by Mayor Speer in 1909 that documents how and where city funds were spent via articles, maps, charts, and photographs under various titles until 1931. Some criticized the magazine for its "boosterism" and alleged political bias. Its June/July 1920 issue highlights Washington Park with this cover image. (*Denver Municipal Facts.*)

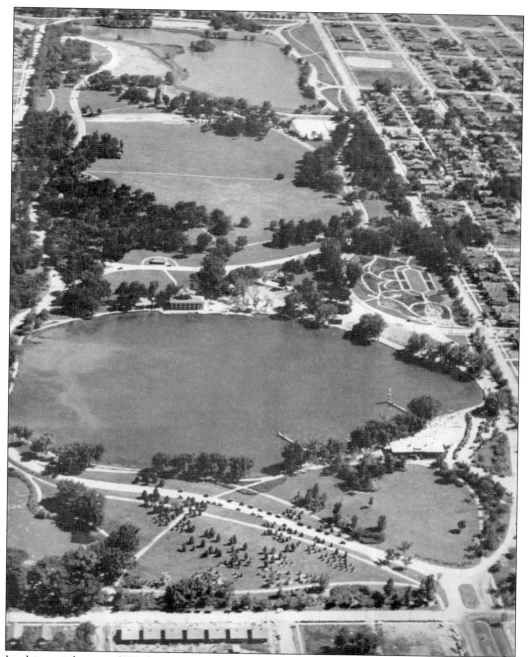

In this aerial view of Washington Park from the 1920s, the Great Meadow—centered in the image and nestled between Smith and Grasmere Lakes—appears similar in size to the lakes. The landscaping design for the Great Meadow was based on Reinhardt Schutze's plans created between 1901 and 1907. Today, the Great Meadow is in high demand for youth and adult soccer, volleyball, and other contemporary sports. (*Denver Municipal Facts*.)

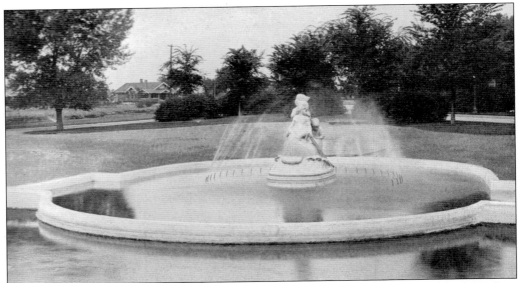

Mabel Landrum Torrey of Sterling, Colorado, immortalized Eugene Field's poem "Wynken, Blynken, and Nod" with this marble statue commissioned by Mayor Speer in 1918. Considered her most famous work, the sculpture was placed in a 25-foot-wide pool centered in Washington Park. In the early 1980s, the Park People financed the statue's renovation and move to a site near the Eugene Field cottage, so the shoe now faces west overlooking Smith's Lake. (*Denver Municipal Facts.*)

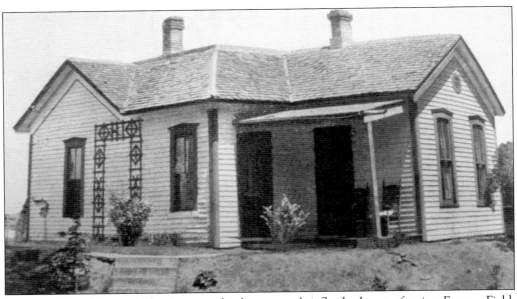

Built in 1875 on West Colfax Avenue, this house was briefly the home of writer Eugene Field. It was slated for demolition in 1927, but members of the Denver branch of the National League of American Pen Women urged that it be saved as a memorial. In 1930, Molly Brown took up the cause by buying the cottage and giving it to the City of Denver to be placed in a park and preserved. (*Denver Municipal Facts.*)

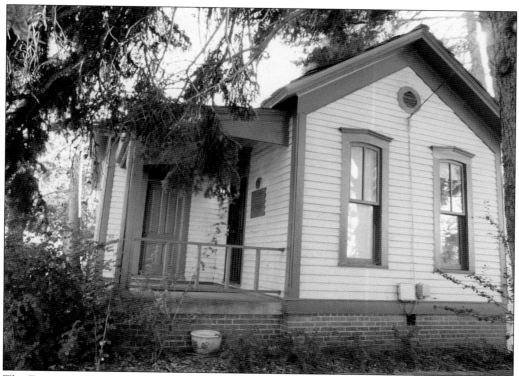

The Eugene Field cottage was moved to Washington Park in 1930 and became the local branch library for 40 years. After leaving Denver, Field published his poem "Wynken, Blynken, and Nod" in 1889 about a dream of three children sailing in a wooden shoe. Field's famous poem has been recreated in numerous artistic forms, including a 1938 Disney cartoon and varying musical adaptations. (Author.)

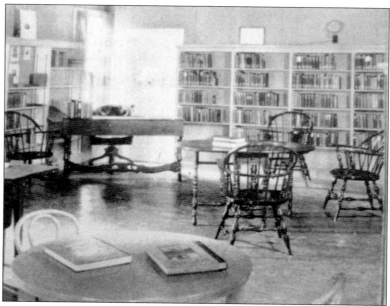

This interior made for a cozy library until 1970. Later, it was the welcoming headquarters for the Park People, a private advocacy organization for Denver's parks and recreation resources. The late-20th-century movement to restore Denver's tree canopy was organized out of this house when Denver Digs Trees was founded in 1991. (*Denver Municipal Facts.*)

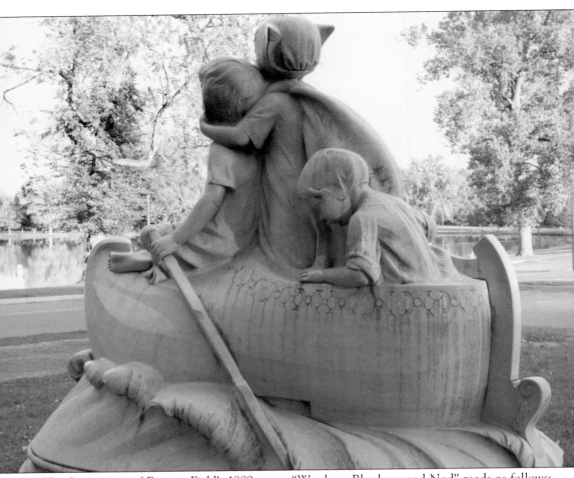

The first stanza of Eugene Field's 1889 poem "Wynken, Blynken, and Nod" reads as follows: "Wynken, Blynken, and Nod one night / Sailed off in a wooden shoe— / Sailed on a river of crystal light, / Into a sea of dew. / 'Where are you going, and what do you wish?' / The old moon asked the three, / 'We have come to fish for the herring fish / That live in this beautiful sea; / Nets of silver and gold have we!' / Said Wynken, / Blynken, / And Nod." (Author.)

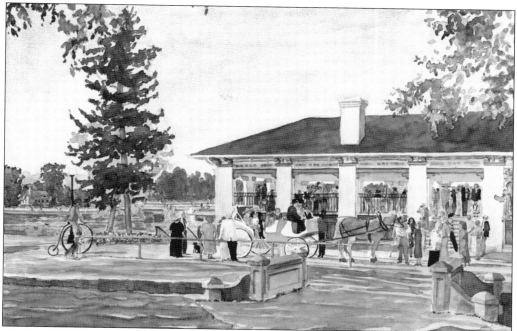

Noted local artist Barbara Froula drew this scene of a Washington Park soiree. The horse and carriage harkens back to the early part of the 20th century, yet this could also be a contemporary scene on summer nights. The Boating Pavilion is a popular setting for celebrations and remains an enduring example of the classical architecture promoted by the City Beautiful Movement. (Courtesy of Barbara Froula.)

This view to the north in the Mount Vernon Gardens in Washington Park shows the perennial flowers in bloom along pathways and stone retaining walls providing symmetry and balance to the landscape features. Generous landscaping is one of the principles fostered in the City Beautiful Movement. (Denver Public Library.)

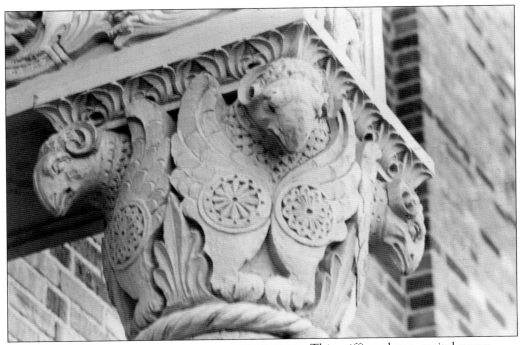

This griffin column capital graces the main entrance to South High School. Elaborate artistic embellishments are enduring examples of City Beautiful principles seen in Denver's public places. (South High Alumni Association.)

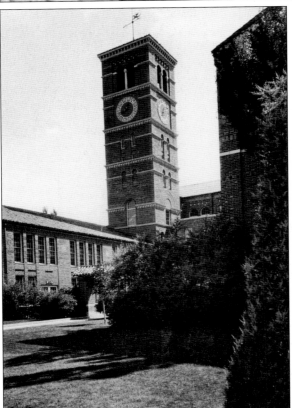

The South High School Clock Tower is visible from many directions. The 1893 World's Fair in Chicago is credited with the adoption of monumentalism (prominent structural features) in American architecture, another principle of the City Beautiful Movement. (South High Alumni Association.)

Denver Planning worked closely with the school district from 1910 until World War II to incorporate City Beautiful concepts into school properties. This collaboration resulted in the use of the highest quality of design, craftsmanship, and materials in the area's school buildings, which signifies the importance the community places on educating its children. This image shows a side entrance to South High School with an arched terra-cotta–embellished doorway. (*Denver Municipal Facts.*)

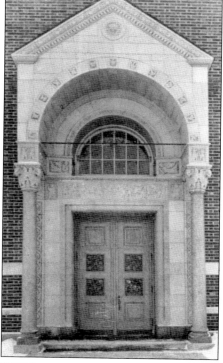

These leaded-stained-glass doors were a gift to Steele Elementary School by the class of 1939. The principle of combining art into architecture as depicted in these doors invokes another City Beautiful principle. The private donation of art for use in public buildings or spaces is common in Denver's version of the City Beautiful Movement as fostered by Mayor Speer. (*Washington Park Profile.*)

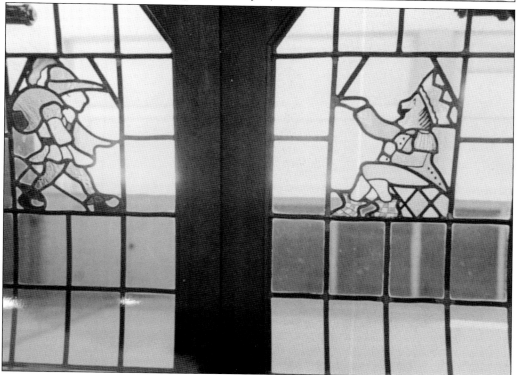

This view of South High School from Washington Park across the City Ditch provides ongoing enjoyment to park visitors. Enhanced vistas were an essential feature of Denver's City Beautiful urban planning as implemented by city planning commissioner S.R. DeBoer, who also served as Denver's second landscape architect. (South High Alumni Association.)

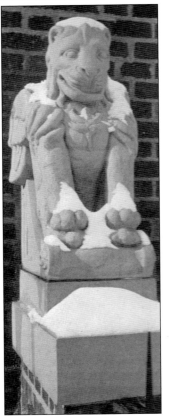

This carved stone statue guards a side entrance to South High School. Public and private contributions to the City Beautiful effort were encouraged by Mayor Speer's "Give While You Live" campaign, resulting in numerous donations enjoyed today by Denver's residents and visitors. (South High Alumni Association.)

Murals can be found in and on public buildings, including the local post office. This one on the kindergarten walls in the Steele Elementary School was painted by Colorado-born Allen True. Colorado's "most noted native artist" began as a magazine illustrator, and his other murals can be viewed in the Colorado State Capitol, Denver's Brown Palace Hotel, and South High School. (Author.)

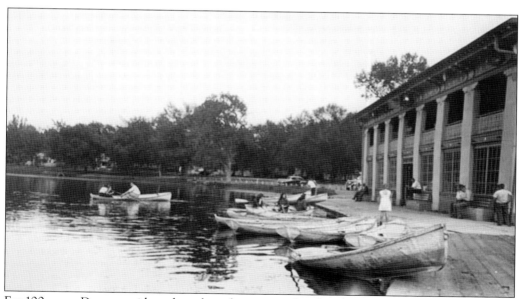

For 100 years, Denver residents have been boating on Smith Lake, shown here in this late-1940s view of the Boating Pavilion in Washington Park. Access to fresh air was an important component of the City Beautiful Movement. Mayor Speer's vision for Denver added recreational amenities such as playgrounds, tennis courts, golf courses, excursion boats, and playing fields as Denver implemented the City Beautiful Movement. (South High Alumni Association.)

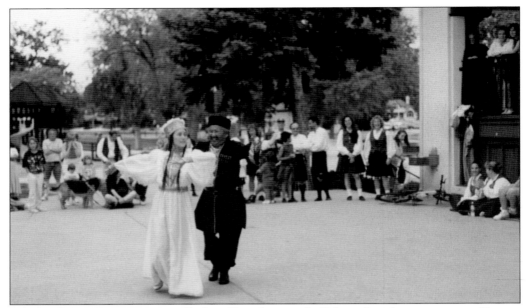

Schukr "Sugar" Basanov, originally from Yugoslavia and of Mongolian descent, came to Denver like so many others for the dry air. Sugar began teaching folk dancing at the Washington Street Community Center. Beginning in the summer of 1971 and for the remainder of the 20th century, Sugar engagingly taught anyone the many varieties of folk dances every Thursday evening on the patio at the Boating Pavilion in Washington Park. (*Washington Park Profile.*)

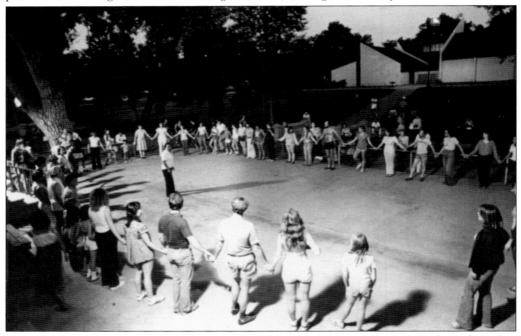

Over the decades, thousands have learned folk dancing here. As many as 200 people might gather at the Boating Pavilion to be instructed by Schukr Basanov. The Basanov family continues the dance-lesson tradition started in 1971 into the 21st century. (*Washington Park Profile.*)

Cottonwood saplings were Denver's first "street trees" along Park Avenue starting in 1867. In the 1980s, after the decimation of thousands of elm trees in Denver, the tradition of planting street trees was renewed in Washington Park by the Park People. (*Washington Park Profile.*)

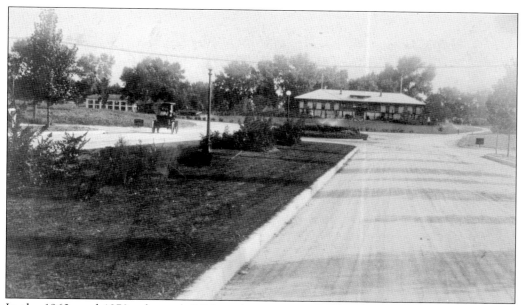

In the 1960s and 1970s, the park fell into disrepair, misused by the public and the city alike. After the bathhouse was vacated (seen here around 1915), it was used sporadically as office space before being abandoned again in 1991. As in the 1880s, South Denver residents in 1992 formed a committee to identify acceptable reuses. Volunteers for Outdoor Colorado paid to renovate the bathhouse as its headquarters in exchange for a 30-year lease. (Denver Public Library.)

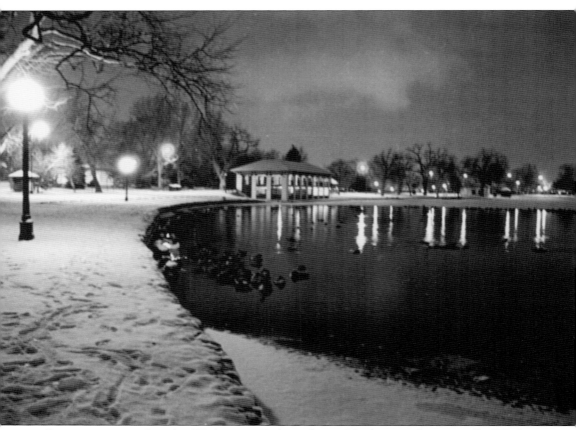

On a snowy winter's night, Washington Park is a beautiful, pleasant place to walk. (*Washington Park Profile.*)

Four

SOUTH HIGH SCHOOL

South Side High School came into being in1893 when two rooms were set aside in the Grant School built in 1890 at South Pearl Street and Colorado Avenue. At the time, Denver was a city in Arapahoe County. School districts were and are wholly separate political entities unto themselves. Originally, Cherry Creek was the geographical divide between the first school districts, No. 1 and No. 2. In October 1862, District No. 2 was formally organized for those families living on the south or west side of Cherry Creek, the area now comprising Washington Park.

District 2 was the first to have a school building when it leased a two-story structure on the north side of Larimer Street between Tenth and Eleventh Streets in December 1862. Overcrowding, even in Denver's earliest days, prompted the district to purchase another two-story building within three years. Built in 1861, this building was converted for school use on land that today is part of the Auraria Campus at Eleventh and Lawrence Streets and was initially called the Arsenal School.

In 1880, District 2 built Central School at Kalamath Street and Twelfth Avenue within which it established its first high school classrooms, celebrating its first graduating class in June 1884. The continuing demand for more high school education resulted in District No. 2 building its first all–high school facility, the Franklin School, in 1883 on West Colfax Avenue at Lipan Street. For some students living south of what would become Washington Park, this meant a four-mile trip to get to school. In 1892, District No. 2 built West High School at Fifth and Fox Streets, and the Franklin School was later converted to administrative offices.

In 1871, District No. 7 was established from within the original District No. 2 boundaries to serve students in grades one through eight who lived in the area south of what is now Mississippi Avenue. The first schools of this district were sited close to the South Platte River. In 1883, James A. Fleming, before becoming the first mayor of South Denver, was elected president of District 7. In 1885, he arranged for Fleming Grove Elementary School, which taught 40 students in the first and second grades, to be built on South Grant Street at Colorado Avenue.

In 1890, District No. 7 built Grant School for grades one through eight. In 1893, two classrooms were designated for this area's high school students, and were known as South Side High until 1923. In 1907, an addition was built onto Grant School for the 125 high school students. Its first class of six students graduated in 1908. Overcrowding continued to be an issue, so a new elementary school was built nearby in 1920, allowing the Grant School to become a dedicated junior/senior high school.

In 1921, a new junior high school called Byers Junior High was built north of Alameda Avenue at 150 South Pearl Street. Then, in January 1926, a new and wholly separate high school, South High School, opened at its current location at the south end of Washington Park on South Franklin Street and Louisiana Avenue.

Glimpses of images collected over the last 100 years convey South High traditions that have gained importance over the decades. Traditions such as Purple and White Day, Homecoming, musical and theatrical productions, yearbook signing, school newspapers, and athletic rivalries (particularly with East High School) connect generation after generation of South High students spanning 120 years. Its vibrant alumni association is a tangible representation of the loyalty felt by so many for more than a century.

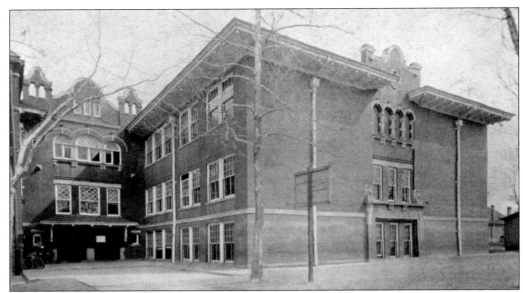

South Side High School was first part of Grant School, initially built in 1890 as an elementary school for children living south of Alameda Avenue, the southern boundary of Denver's city limits. In 1893, two rooms of the elementary school were set aside for use as the high school. (*Aeronaut*, 1923.)

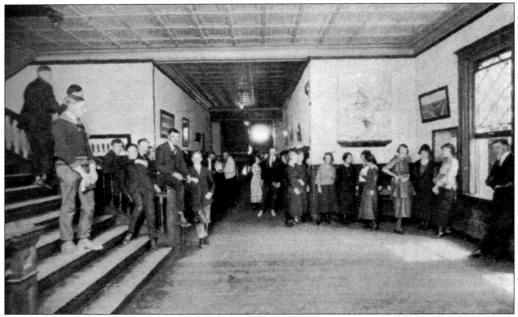

The interior entrance of "Old South," pictured here in the first edition of South Side High's yearbook, the *Aeronaut*. The title is inspired by the Latin *Alis volat propiis*, meaning, "She flies with her own wings." In its first pages, the yearbook speaks to the 1893 school building's overcrowded conditions and obsolete architecture. Despite the "inadequate" facilities, the students claim to love every brick, every creak, and every door and window. The school district used this building as Grant Junior High School until after World War II. (*Aeronaut*, 1920.)

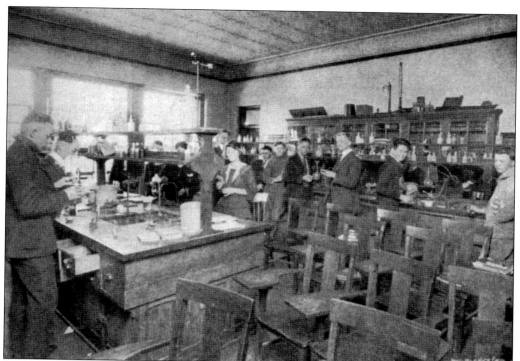

Here, students in 1920 are pictured in their science lab in Old South. This building was one of the first schools in District 7. (*Aeronaut*, 1920.)

This junior from Denver's South Side High School wears his letter sweater in 1920 with the same pride as today's South High athletes. (*Aeronaut*, 1920.)

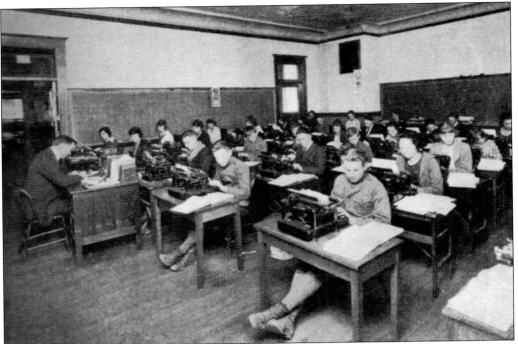

In the 1920s, more males than females held secretarial positions. This photograph shows both practicing their typing skills in Old South. (*Aeronaut*, 1920.)

This image shows what may have been the principal's office in Old South. Note the coved ceiling covered with tin as a sound barrier and the single lightbulb hanging from the room's only visible light fixture. (*Aeronaut*, 1920.)

Davis MacArthur Carson was a beloved teacher who came to Old South in 1905 and eventually served as its principal until 1919. His sudden death in May of that year was a shock to all. A Denver elementary school is now named in his memory. (*Aeronaut*, 1920.)

A review of any South High yearbook will reveal the popularity of the school's drama program. Plays, musicals, poetry readings, and concerts remain an integral part of student life at South High. This student actress plays her part in 1920. (*Aeronaut*, 1920.)

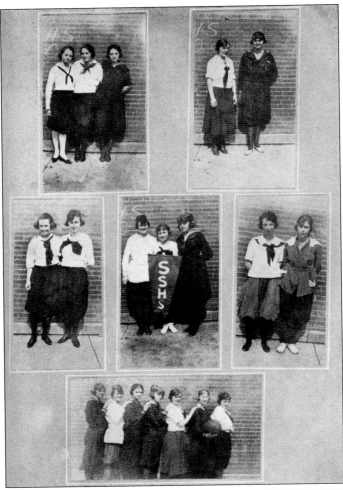

This South Side High girls' basketball team won every city game of its 1919–1920 season. (*Aeronaut*, 1920.)

This image shows some of the South Side High baseball players in 1920. (*Aeronaut*, 1920.)

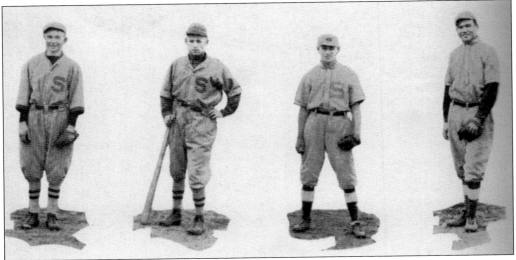

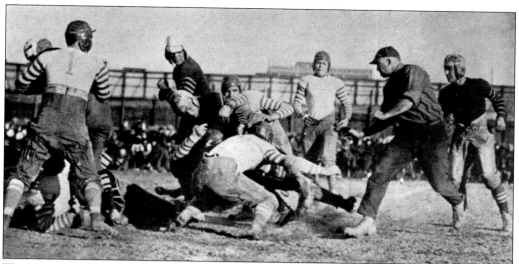

The 90-year rivalry continues between South High and East High, and this *Denver Post* photograph captures a football game between the two in 1922. (*Denver Post* photograph in *Aeronaut*, 1923.)

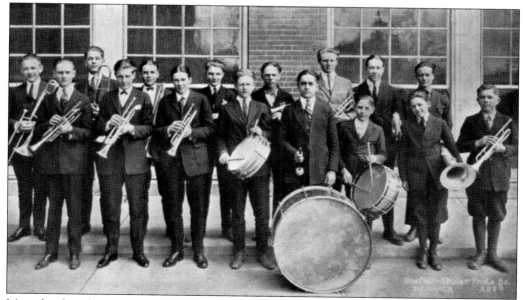

Music has long been an important component of Denver schools. Here is South Side High's band from 1923, the year the school's name was changed to South High. (*Aeronaut*, 1923.)

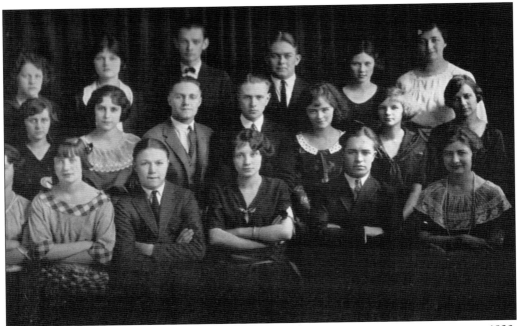

Clearly, the work of the student council is taken very seriously by its representatives in 1923. (*Aeronaut*, 1923.)

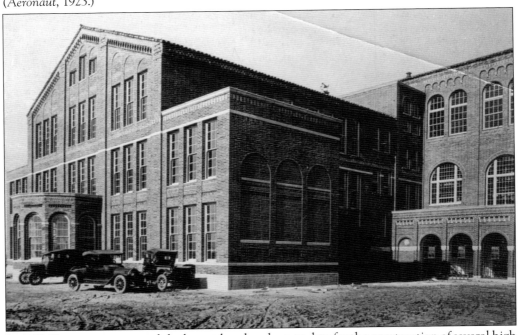

In 1923, Denver voters passed the largest bond package to date for the construction of several high schools, junior high schools, and elementary schools, including the construction of a new South High School located just south of Washington Park. The schools built or remodeled with these bond funds all demonstrated the City Beautiful concepts of incorporating art into architecture. (South High Alumni Association.)

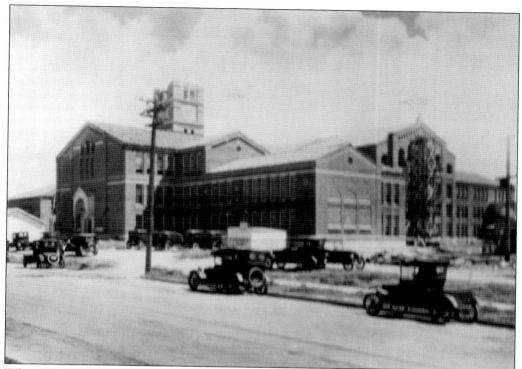

When South High School was under construction in 1925, Louisiana Avenue, seen in the foreground, was still a dirt road. For 86 years, South High parents have been driving here to gather their students after school or from extracurricular activities. (*Washington Park Profile*.)

This official image shows South High School as it looked when welcoming students in January 1926 to their brand-new building designed by locally acclaimed architects and brothers Fisher and Fisher. Displaying an unusual blend of northwestern Italy's Lombardy style of architecture with Romanesque Revival influences, this building embodies many of the City Beautiful Movement principles and serves as a monumental symbol of the importance this community places on education. (Denver Public Schools.)

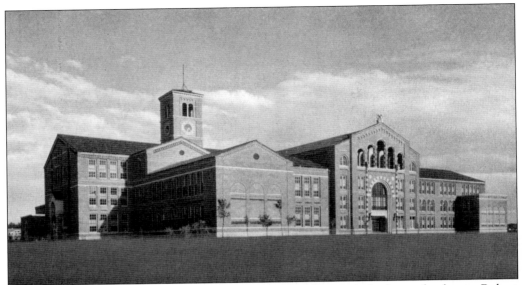

Embellishments in and on the South High School building include the work of artist Robert Garrison. The soaring griffin perched over the main entrance serves as the school's protector and is flanked by two friezes, titled *Faculty Row* and *Animal Spirits*. The monumental clock tower and the school's use of statuary, murals, and numerous terra-cotta exterior embellishments amid its own spaciously landscaped grounds extend the parklike atmosphere to student activities. (Denver Public Schools.)

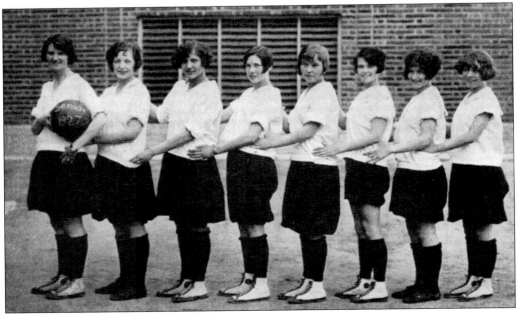

The new building seems to have spurred on the senior girls' basketball and soccer teams to another championship year in 1927. Note the high-top shoes worn by these basketball players. (*Aeronaut*, 1927.)

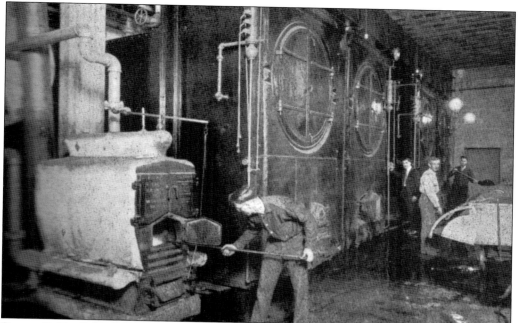

Denver Public Schools plan for their buildings to last 100 years. Today's students at South High can attest that this heating system continues to do its job—sometimes only too well—after 85 years of service. (*Aeronaut*, 1927.)

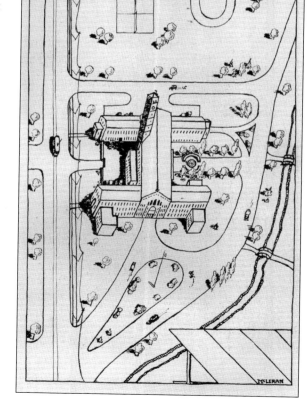

An early design for South High School's spacious grounds is seen in this 1927 student-drawn bird's-eye-view sketch of the campus. The now buried City Ditch is visible to the right on the drawing, complete with bridges. It is said that a frequent school prank was to toss fellow students into the ditch. (*Aeronaut*, 1927.)

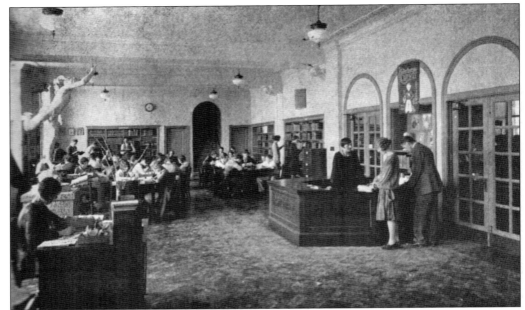

Influence of the City Beautiful Movement is evidenced in this photograph of the school library, with statuary on the left side of the room. With the soaring two-story windows, librarians and students alike have a panoramic view of Colorado's Front Range. (*Aeronaut*, 1927.)

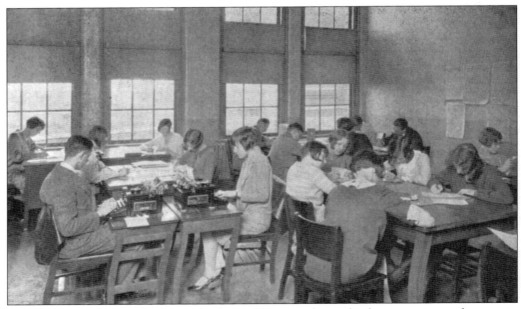

School newspapers, yearbooks, and other publications have also been consistent features in South High's history. These are members of the *Aeronaut*'s staff working in their office in 1927. (*Aeronaut*, 1927.)

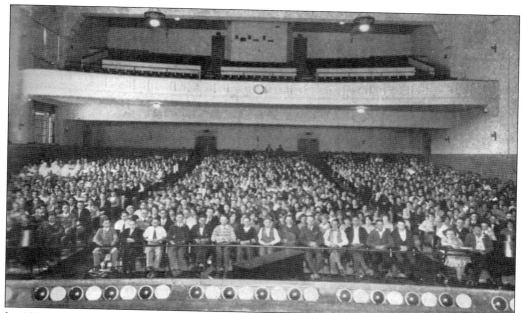

In 1927, the students finally had an auditorium where they could all attend an assembly or performance together. Seating almost 2,000, the auditorium remains in high demand for community and political meetings today. (*Aeronaut*, 1927.)

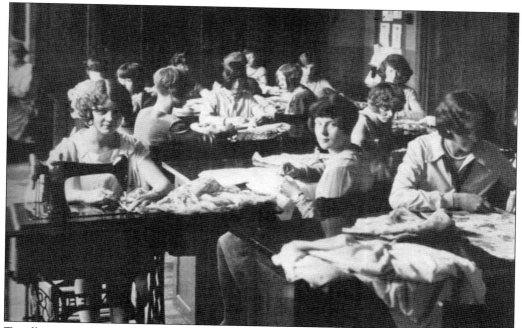

Treadle sewing machines are being put to good use in this 1928 sewing class. Note the bobbed haircuts, a new look that was unlikely to have been well received by parents at the time. (*Aeronaut*, 1928.)

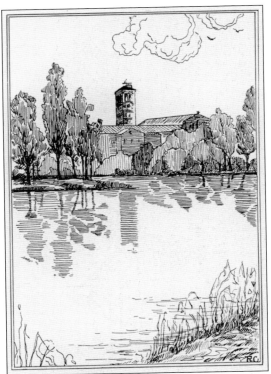

The first yearbooks were called annuals and included numerous works of original art and prose produced by students. This pen-and-ink drawing, which provides a view of the new school from the west side of Grasmere Lake in Washington Park, was the work of senior Winston Ausenbaugh. (*Aeronaut*, 1928.)

This area has been used both as the teacher's lounge and by the Girls League. South's Girls League was organized to bring the girls in touch with each other and to guide them in their school life through get-togethers and regular programs and speakers. Note the rocking chairs and piano. (South High Alumni Association.)

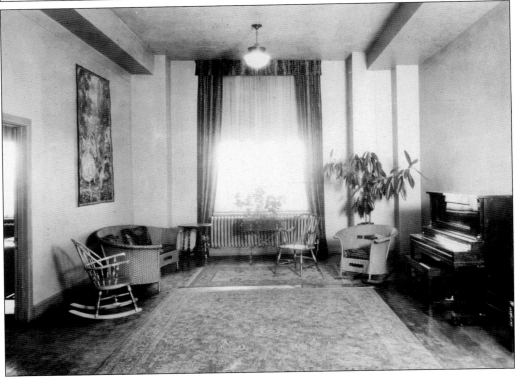

Notice the hour symbols on South High School's clock face are representations of the 12 signs of the zodiac rather than numerals. As one of only two clocks like it west of the Mississippi River, it has been restored and is maintained by the South High Alumni Association. Retired rocket scientist Richard Maginn, class of 1942, served as the master clock keeper for many years and recently trained his successor, Judy Hatfield-Mihelic, class of 1968. (*Aeronaut*, 1928.)

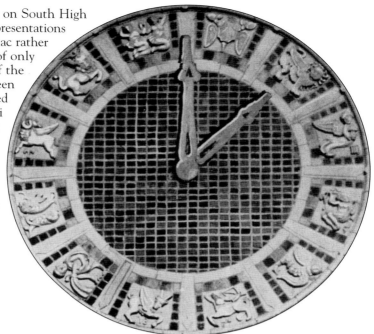

Being popular appears to be a timeless and universal high school concern. Some people have fond memories of their high school days; others cannot wait to forget them. Pictured here are Warren Rossman and Hope Watson, the popularity contest winners for 1939. (Nita Jean Molberg.)

Students enjoy their high school's parklike setting, another feature of the City Beautiful Movement, in 1941. (*Southerner*, 1941.)

South's school grounds are a great place for students and residents to gather and visit with friends. This statue base makes for a semiprivate but sunny place to meet. (*Southerner*, 1941.)

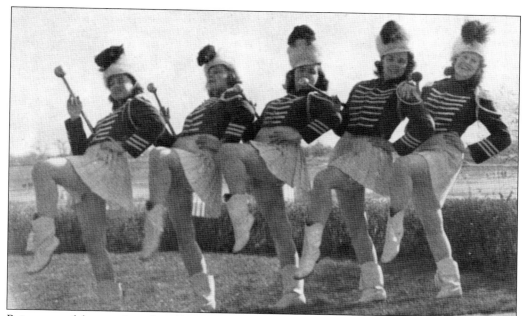

Being part of the marching band has remained a fun activity for South High students. This group of majorettes is pictured in 1941. (*Southerner, 1941.*)

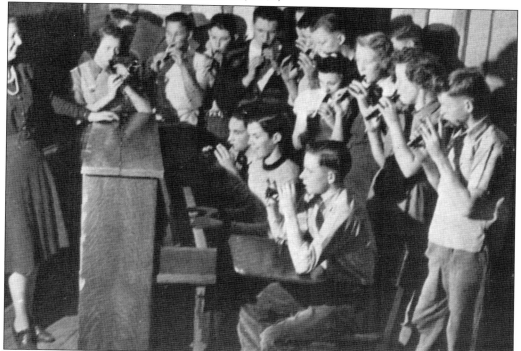

This group of students huddled by the piano in 1941 shows how music has been a long-standing and important part of the South High School experience. There remains a very active alumni choir that practices and performs on a regular basis, particularly during the winter holidays. (*Southerner, 1941.*)

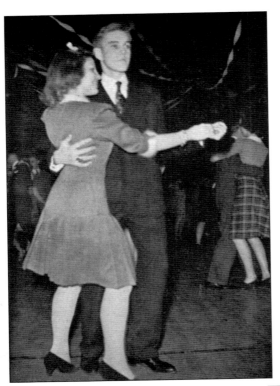

There are reports of many dances held at school for students in the 1940s and 1950s. This is a couple at a school dance in 1941. (*Southerner*, 1941.)

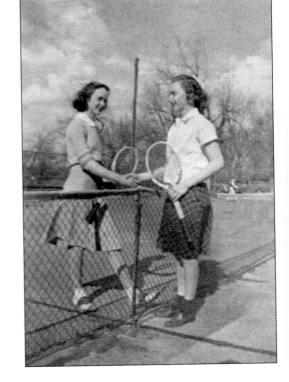

People have been playing tennis in the Washington Park neighborhoods since before 1909. These tennis players from 1941 seem to be taking advantage of another sunny Colorado day. (*Southerner*, 1941.)

One locally famous South High graduate of the class of 1941 was radio and newspaper personality Gene Amole (Francis Eugene Jr.). Gene had a radio show, and one of his listeners was sophomore Nita Jean Charon, who remembers taking the streetcar with friends to watch Gene spin the records. Later in life, Gene wrote of his fond memories as a "Highlander Boy." (*Southerner*, 1941.)

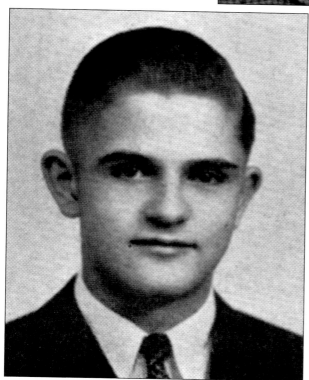

Gene's classmate Leonard Molberg grew up in the 1700 block of South Pennsylvania Street. Leonard was a South Sider all the way through school, beginning with Thatcher Elementary (now condominiums) just west of South Logan Street. He then went to Grant Junior High and, finally, to South High (class of 1941). According to his wife, Nita Jean, Leonard remembers the streetcars on South Pearl Street would "get to rockin' and end up leaning on a front porch after coming off their tracks." Leonard played trumpet in a dance band. (*Southerner*, 1941.)

97

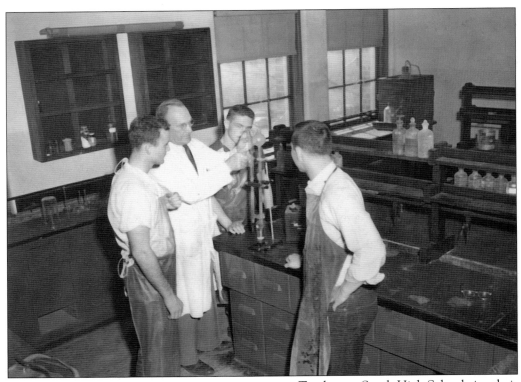

Teachers at South High School give their students their best attention, as seen here in the science lab in the 1950s. (South High Alumni Association.)

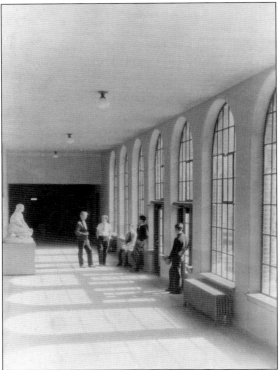

Keeping up with the City Beautiful Movement, Senior Hall, like the library, had its own statue. It was tradition that only seniors could pass through this hall. (South High Alumni Association.)

By the 1940s, the band uniform had changed, and girls were counted among the musicians. (South High Alumni Association.)

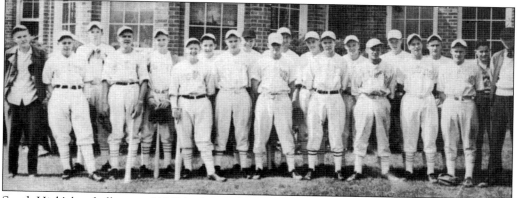

South High's baseball team of 1943 had a win-loss record of 4-4. Shown here with Coach Waldman, the team twice played each of Denver's other four high schools at the time—East, West, North, and Manual. (Nita Jean Molberg.)

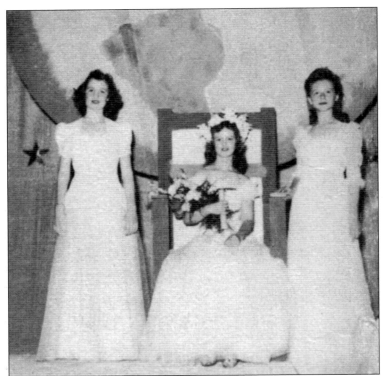

Fay Wickstrom was crowned South High School's Purple and White Queen for 1943. She is seen here with her court in May of that year. Purple and white are South's school colors. Today's students continue to show their school spirit, especially on Purple and White Day. (Nita Jean Molberg.)

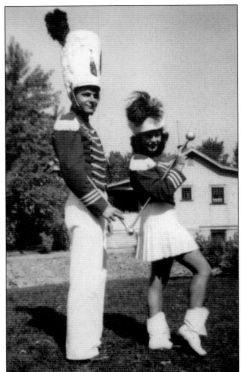

This 1940s image shows an unidentified drum major with Doris, a majorette. (South High Alumni Association.)

Here is another dance show at South High in 1944. This was before the days of television and long before the Internet; now, people no longer need to leave home to be entertained. (South High Alumni Association.)

For many years, all students had the opportunity to learn to shoot. Here are girls practicing in the basement rifle range, now a space used by the alumni association. (South High Alumni Association.)

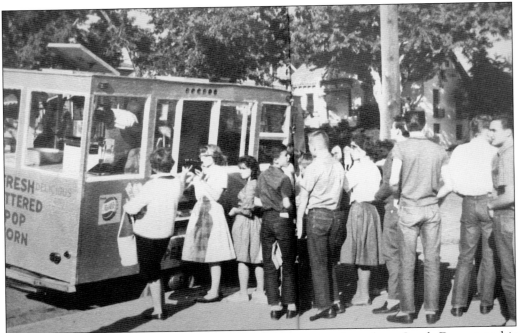

In the 1920s, the popcorn man drove a horse-drawn wagon throughout South Denver on his daily rounds. Eventually, he converted a Model T to serve as his popcorn wagon. He is seen here in 1964 enticing students with his snacks. (South High Alumni Association.)

South High has a very strong and active alumni association. Besides helping to organize reunions, these neighbors keep track of other alums, give tours, and ensure the preservation of memories of years past. (South High Alumni Association.)

Five

SOUTH SIDE IMPROVEMENT SOCIETY

Denver's Washington Park sits in a central location where trails developed along the creek and river, followed by wagon roads, railroads, streetcar and trolley routes, interstates, and light rail. As transportation modes developed and eased movement, manufacturing and businesses arrived to serve the residents.

South Denver was permanently settled by people who took an active role in shaping their community. Individuals carved Broadway, planted trees, built bridges over Cherry Creek, established school districts, and created a separate town to protect and sustain the quality of life they desired. When times went bust in 1893, they swallowed their pride and asked to be annexed to Denver in order to access more affordable water and sewer systems. A decade later, in 1903, even their school systems were folded into Denver's.

Despite agreeing to be subsumed, the community south of Cherry Creek and along Broadway kept an independent mind-set that segregated it from other sections of the city. Over a 130-year span, South Denver residents have organized more than a dozen civic organizations or clubs that have alternately fostered or disdained specific political or business agendas. The South Broadway Union Club, begun in 1884, set the stage for activism that continues through the 21st century. The South Denver Civic Association, with 800 members and a "Go South" motto, was a 20th-century force in the area that, when not pursuing other agendas, organized carnivals, festivals, and movie nights to bring crowds to South Denver. Current merchant associations along Broadway, South Pearl Street, and South Gaylord Street, in particular, have, in conjunction with neighborhood organizations surrounding Washington Park, taken up the gauntlet to sustain the vitality and desirability of their neighborhood.

Complementing the continuing volunteer work of these civic and merchant organizations have been a myriad of publications, usually weekly papers, about and for South Denver. Beginning with the first issue of the *South Denver Advocate* in March 1884, which gives an accounting of the first meeting calling on South Broadway residents to "take action toward advancing the public welfare of this area," these publications have promoted, ignored, or given voice to the business or civic efforts in South Denver. The result of that first neighborhood meeting was the formation of South Broadway Union Club, where "the seed was sown that has since brought forth rich fruitage." Since 1978, the neighborhood-newspaper role has been predominantly held by the *Washington Park Profile*, whose monthly, 30-page editions are available to 16,000 residents.

The mid–20th century in South Denver was a time of serious decline in business and residential value and public investment in park amenities. The Washington Park Bathhouse was shuttered and vacated, its lily pond neglected along with park statuary. Denver's zoning code was liberalized to allow the construction of apartment buildings in historically single-family zones. Broadway and residential streets were converted to one-way speeding thoroughfares promoting the commute to the suburbs.

In the 1970s, much like in the 1880s, the people who lived in South Denver around Washington Park took action when the future of their neighborhood was threatened. Like their 19th-century counterparts, they changed the roads, planted trees, cajoled city government, worked to improve the schools, and helped restore and maintain Washington Park. The January 1, 1890, *South Denver Eye* describes the group of activists who started South Denver: "It was the beginning of that united and earnest effort to secure public improvements that has characterized the South Siders from that day to this." So it continues today.

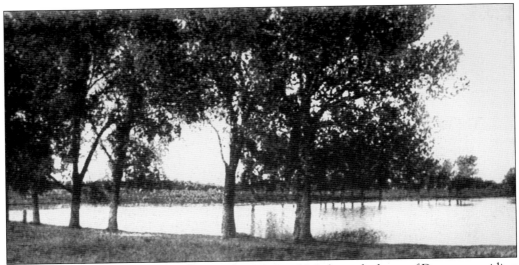

By 1867, the Big Ditch was running water through Smith's Lake to the heart of Denver, providing irrigation to farms and lawns. Access to water brought settlers, and settlers brought development. The only road to downtown, County Road 30 (now Santa Fe Drive), had become congested with people and produce trying to make their way to downtown. (*Denver Municipal Facts.*)

To avoid congestion along what is now called Santa Fe Drive, a new route was needed; thus, Broadway was born in 1871 when Tom Skerritt and others cut a new roadway and laid planks across Cherry Creek. Now, the earliest South Siders had a more direct route into downtown. This is a view of South Broadway from Alameda Avenue sometime before 1890. (Denver Public Library.)

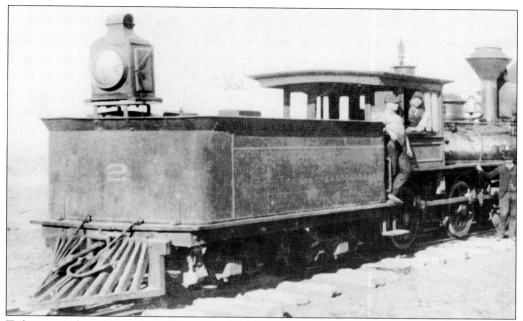

To bring rapid transit south of Cherry Creek, the Denver & New Orleans Railroad was established in 1881 along what now is Buchtel Boulevard. This laid out the path for the interstate that would be constructed 80 years later, which now is eight lanes wide with light-rail rapid transit aligned along this corridor. (*Washington Park Profile.*)

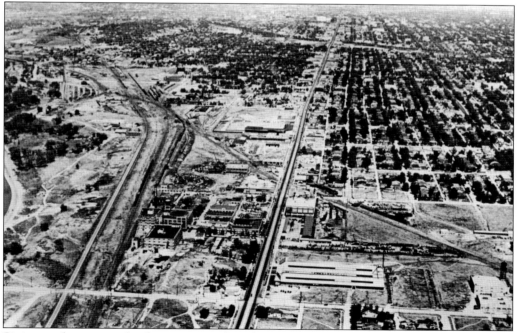

Sitting at the crossroads of a river, a creek, railroad lines, trolley routes, and now an interstate highway with commuter rail has brought both blessings and curses for this area of Denver. (*Washington Park Profile.*)

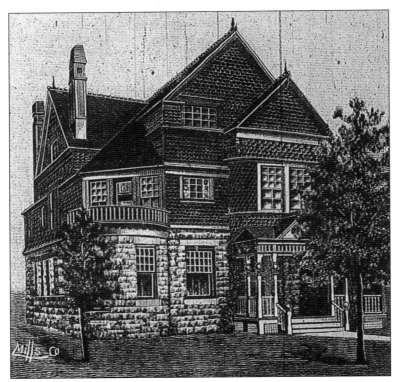

With pure water and a new roadway with access to downtown, the area south of Cherry Creek was soon developed. With the opportunity to be away from the dirty Denver air caused by smelting and congestion, up-and-coming businessmen such as E.B. Field chose to build their homes here. This house sat at Broadway and Alameda Avenue in 1890. (*South Denver Eye.*)

William M. Dailey arrived in Cherry Creek, Kansas Territory, in 1859. According to the *South Denver Eye*, he arrived when Denver was "just in the throes of birth." He ranched on the Platte bottom, like William Byers, until the flood of 1864. Dailey was one of 40 petitioners to sign the incorporation of the Town of South Denver and served several terms as president of the Citizens Association of South Denver. (*South Denver Eye.*)

T.S. Murray built his house at 343 Broadway before 1890 in a modified Queen Anne style. Local historian Barbara Norgren suggested that Denver buildings represent a blend of architectural styles and not a pure design of any one style. The mix of housing styles evident today in the neighborhoods surrounding Washington Park continues to provide a tantalizing walking experience for current residents. (*South Denver Eye*.)

T.S. Murray was another of the 40 petitioners on the incorporation of the Town of South Denver and an active South Sider. He was chosen school director of District 2 and later served as chairman of the school board's finance committee and as a member of the building committee. From his handsome home on Broadway, he also served as vice president of the Citizens Association of South Denver. (*South Denver Eye*.)

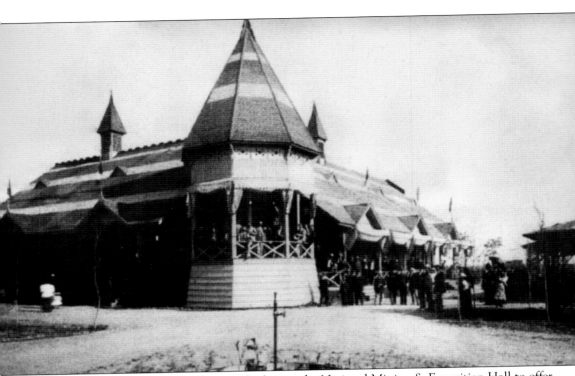

The Sans Souci Concert Gardens was built near the National Mining & Exposition Hall to offer entertainment and refreshments to attendees. At the time, Denver sported a saloon-to-church ratio of eight to one. The South Broadway Union club targeted San Souci's liquor license application in March 1884 to no avail. The establishment flourished until 1887 and burned down in 1893. To keep the south side of Cherry Creek free of saloons, the Town of South Denver was incorporated. Today, South Denver's neighborhood representatives volunteer hundreds of hours annually in a continuing struggle to contain liquor license applications in this popular residential area. (Denver Public Library.)

The *South Denver Advocate*, the first paper published south of the creek, reported in its inaugural issue on the first meeting of South Broadway residents, held March 15, 1884, to advance the public welfare of the area. A.E. Pierce, publisher of the *Advocate*, also founded the *South Denver Eye*, the "oldest established suburban paper in Arapahoe County, giving voice to South Siders through the end of the 19th century." (*South Denver Eye.*)

When the horsecar company changed its Broadway service route in 1887, a committee of Broadway citizens vigorously protested. Although laughed at for their complaint, committee members successfully negotiated with the fledgling electric cable car company for the extension of its railway down Broadway. One outcome was this cable car loop at Alameda Avenue. (*Washington Park Profile.*)

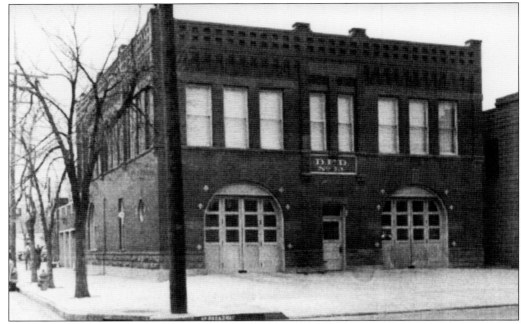

The members of the South Broadway Union Club were the petitioners for the incorporation of South Denver. Their earnest efforts to secure public improvements, including facilities such as Firehouse No. 13 (pictured), sowed the seeds that, as the *South Denver Eye* noted in January 1890, "ha[ve] since brought forth rich fruitage." This statement rings true 120 years later. Dating from 1891, this firehouse still stands on South Broadway at Bayaud Avenue. (Denver Public Library.)

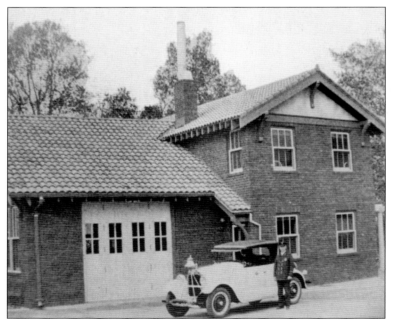

The original much-beloved Firehouse No. 21 was located at the northeastern corner of Washington Park, adjacent to the Lily Pond. Completed in 1924, its unannounced demolition has served as a "rallying cry" since 1975 for cynical neighborhood residents who believe that local public officials do not always listen to their constituents. (Denver Public Library.)

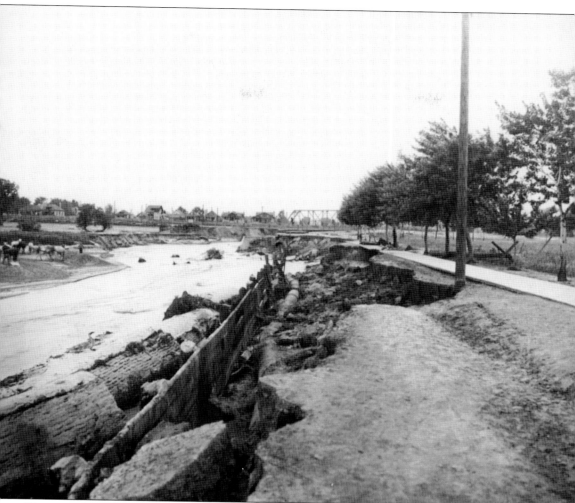

This image, with a view looking west from First Avenue toward Lafayette Street, shows the effects of the July 1912 flood along Cherry Creek. South Side residents would pester the city to secure new bridges and sidewalk improvements like they continued to bring up "the parks question" until Smith Lake was finally purchased for Washington Park in 1910. (*Washington Park Profile*.)

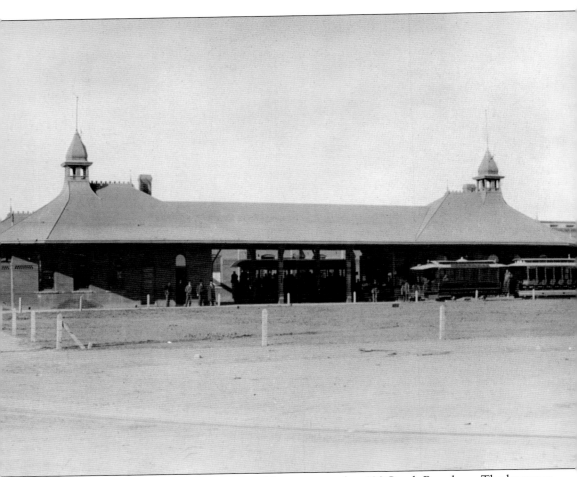

This is the Tramway station that was quickly constructed at 400 South Broadway. The horsecar trolley company tried rerouting service to objecting South Denver residents, who were told they would have to wait not less than five years for cable car service. The *South Denver Eye* reported that horsecar company officials felt the errors of their ways after a committee of Broadway citizens successfully negotiated with a newly created electric cable car company to establish its railway down Broadway. The horsecar trolley officials were roused from their "Rip Van Winkle sleep and went out and kicked [themselves]" for laughing at these intrepid South Denver residents. (*Washington Park Profile.*)

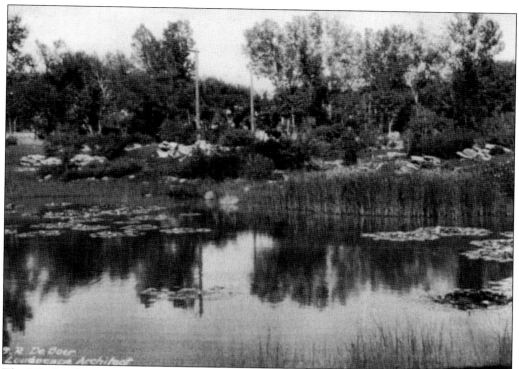

The Lily Pond seen here was the design collaboration between S.R. DeBoer and Frederick Law Olmsted Jr., the son of the famous landscape architect of New York's Central Park. The city maintained this pond until the 1960s, when lily ponds were built at Denver Botanic Gardens. (Denver Public Library.)

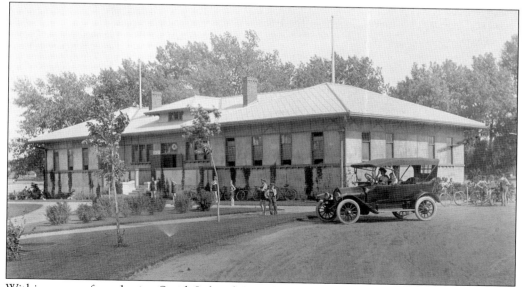

Within a year of purchasing Smith Lake, the city built its first bathhouse, seen here. Use of the facility provided stability to the park and surrounding neighborhoods until it was shuttered in the mid-1950s. (Denver Public Library.)

Henry Wilcox constructed the Downing Street waiting station at Bayaud Avenue in 1904 to shelter those waiting for the trolley. Wilcox painted the structure green to match his home, which still stands across Downing, and maintained the shelter until he died in the flu epidemic of 1918. Six decades later, a band of neighbors repaired the station to prevent the bus company from tearing it down as an eyesore. (*Washington Park Profile.*)

One of the South Denver area's best-known homegrown businesses is Royal Crest Dairy. Established in 1927 by Mr. and Mrs. Sam Thomas at 350 South Pearl Street, this family-owned business is a local landmark. Travelers of South Pearl Street can still view this building, seen here in the 1930s. The Miller family purchased Royal Crest in 1965, and the business now operates under the leadership of the grandson of the founder of the former locally operated Miller's Sanitary Dairy. A century later, the same commitment to high quality and customer service led to the extension of this once South Denver–only milk-delivery enterprise—a harbinger of times past—for 100 miles north and south along Colorado's Front Range. According to the Royal Crest Dairy website, one lifelong customer remembers traveling to the dairy on the South Pearl Street trolley with her mother and siblings and insists that she "'wouldn't dream' of taking anyone else's service." (Royal Crest Dairy.)

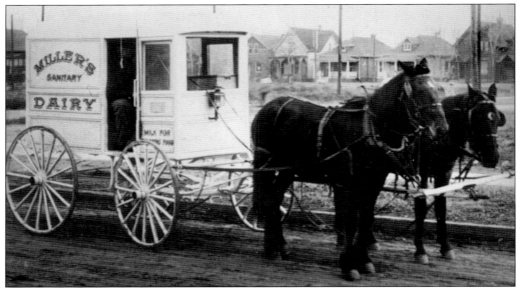

The Miller family first began delivering milk to Colorado families in 1910 when Paul Silas Miller founded Miller's Sanitary Dairy. In each 24-hour period, he milked the cows, bottled the milk, and made the daily delivery from the original location near Evans Avenue on the west side of the Platte River. Now, his grandson Paul R. Miller leads Royal Crest Dairy. Below, the importance of hygiene is evident in this image of the original 1927 bottling machine. Royal Crest has remained committed to the environment; in 1965, it became one of the United States' first dairies to switch to a reusable/recyclable plastic milk bottle, and in 1991, it began converting its home-delivery vehicles to liquefied petroleum gas (LPG), a cleaner-burning fuel that reduces carbon monoxide emissions by up to 80 percent. (Both, Royal Crest Dairy.)

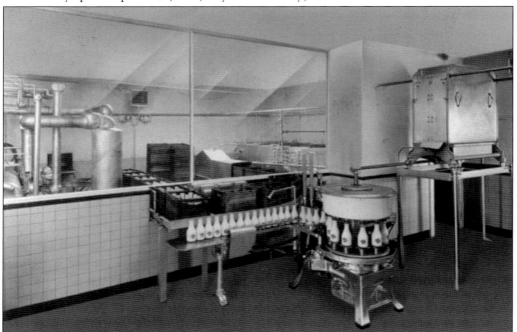

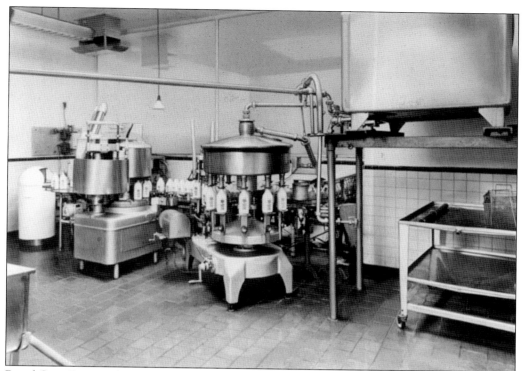

Royal Crest Dairy's plant operation began at the South Pearl Street location and continued there for more than 73 years. Throughout the years, the dairy has worked hard to be a good neighbor while accommodating its expanding business operations. (Royal Crest Dairy.)

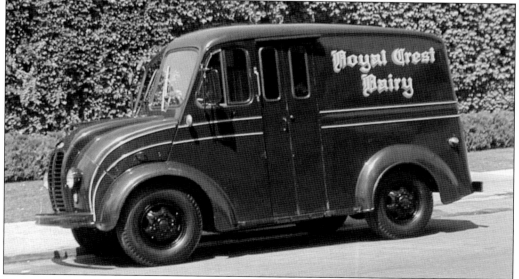

Divco trucks were used to deliver Royal Crest products. This 1955 truck, with its snub-nosed hood, was a familiar sight parked on South Pearl Street or traveling numerous other Denver streets. Divco, an acronym for Detroit Industrial Vehicles Company, first built delivery trucks in 1926 and was known for its pioneering vehicles, now popular collectibles. (Royal Crest Dairy.)

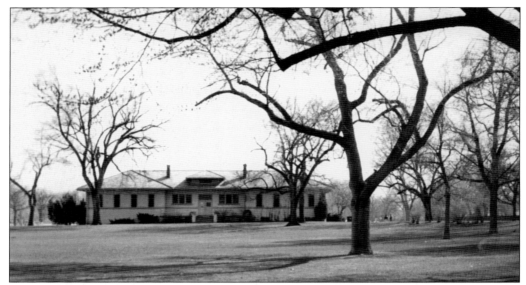

Despite the enduring beauty of the park, change came hard to these neighborhoods in the 1950s. The bathhouse shuttered, Lily Pond was no longer maintained, and park amenities and statuary fell into disrepair. (*Washington Park Profile*.)

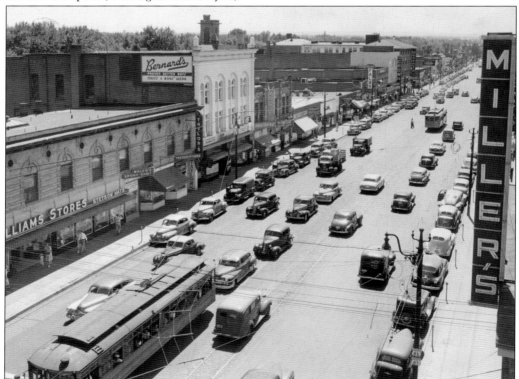

The trolleys too were discontinued in favor of buses, and significant changes were made to Denver's zoning code that allowed high-density, multistoried buildings to be constructed inches from single-story, single-family residences. (Denver Public Library.)

In the 1950s, the federal government divided the north and south portions of the community by cutting through with a new highway, Interstate 25. One-way streets were imposed overnight west of Washington Park to save the city and state highway construction dollars. These once residential streets became thoroughfares for the daily commuters trying to get downtown from the new interstate. (*Washington Park Profile.*)

The view of mountains from Interstate 25 near Downing Street sets Denver apart for travelers of the interstate. (*Washington Park Profile.*)

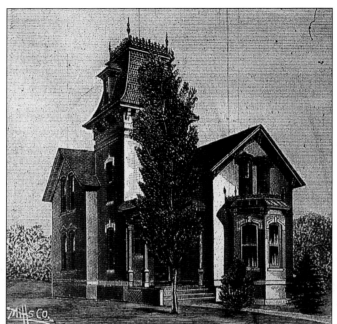

Edward S. Day built his fine residence on the hill east of Broadway at 26 South Pearl Street. He was in the tinning business and was well known for fabricating the "longest gutter in the world," according to an 1890 *South Denver Eye*. His house was razed after Denver zoning changes made in the 1950s allowed high-density structures to be built amid single-family residences. Day's former land now is occupied by an apartment building. (*South Denver Eye*.)

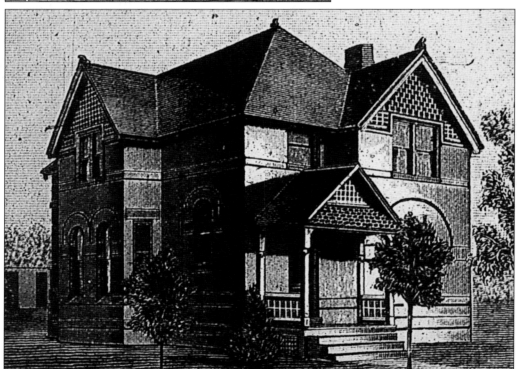

Louis Hessimer owned a large property on Pearl Street in the block just north of Ellsworth, upon which he built this house. He was an active member of the Citizens' Association of South Denver and a strong friend of the South Side. An apartment building, constructed after the zoning change in the 1950s, has replaced this fine residence. (*South Denver Eye*.)

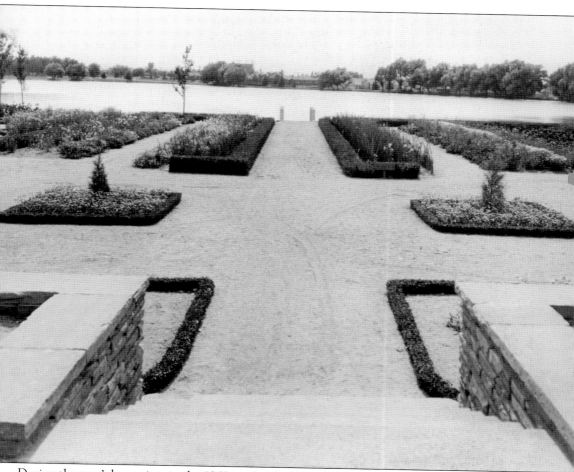

During the area's low points in the 1960s and early 1970s, houses on the west side of Washington Park were redlined by banks, meaning no one could get even a $25,000 loan on a 1910 house that today might sell for $300 per square foot. Some things held the community together: the gardens in the park, the recreational center that replaced the 1911 bathhouse, and the schools, especially Steele Elementary and South High, that drew student population from families living on both sides of Washington Park. (Denver Public Library.)

After the neighborhoods perhaps reached their lowest point in the 1970s amid parents' concerns with court-ordered busing, positive changes started once again. A federal program called Federally Assisted Code Enforcement (FACE) offered South Denver property owners an incentive to bring their 60-year-old houses up to code. The City of Denver removed automobile traffic from Washington Park's inner roadways, and stalwart representatives from many neighborhoods banded together to convince Mayor Federico Peña's administration to reverse couplets of one-way streets back to neighborhood-friendly two-ways streets. (*Washington Park Profile.*)

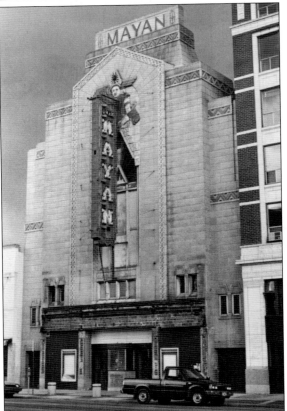

The Friends of the Mayan found a partner in Mayor Peña's administration in their efforts to save the 1931 iconic movie theater from demolition. The theater remains an entertainment destination along Broadway 30 years later. (*Washington Park Profile.*)

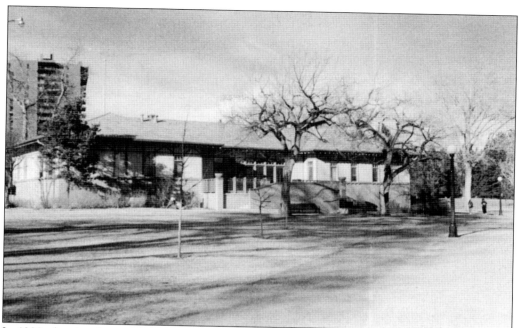

In 1990, the city shuttered the bathhouse again, kicking out a welcome tenant. Another band of neighbors took the initiative to create an acceptable list of reuses, presenting a report to city staff with an implicit warning that a decision to tear down the structure would be fought. A nonprofit organization, Volunteers for Outdoor Colorado, raised $500,000 to rehabilitate the structure in exchange for a 30-year lease. Thus, another landmark was restored. (*Washington Park Profile.*)

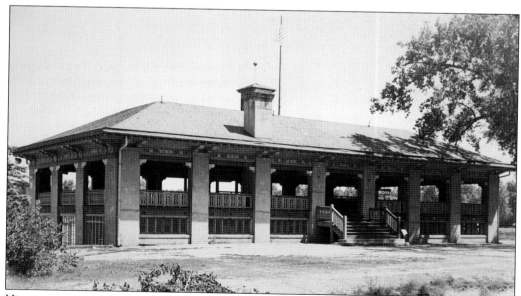

Historic preservationists raised funds to restore the Boating Pavilion to its original glory. People now stand in line in the wee hours of the morning to secure a permit to use the facility for their wedding or party. (Denver Public Library.)

A right of passage for youngsters growing up in the Washington Park neighborhoods is hunting for crawdads in the Big Ditch and the lakes. Beginning in the late 1940s, both the *Rocky Mountain News* and the *Denver Post* organized their own fishing derbies. For almost 40 years, the derbies drew upwards of 5,000 participants each summer. The Colorado Division of Wildlife stocked both lakes until the mid-1980s. (*Washington Park Profile.*)

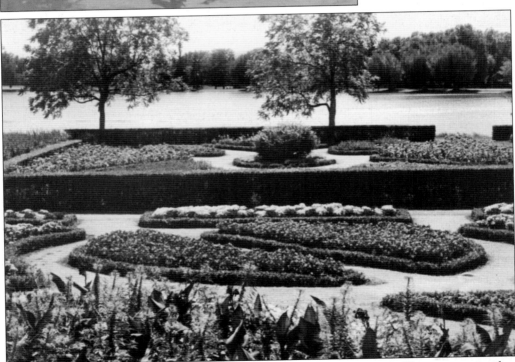

After 80 years of planting flower gardens in Washington Park, the City of Denver sent an alert that it could no longer afford to maintain this park amenity. Neighbors suggested the Denver Parks and Recreation Department instead ask for volunteers to help them "put the beds to bed." That first fall weekend, 300 volunteers arrived to help. Now, after a dozen years, this volunteer task has become another park tradition and has allowed the flower gardens to celebrate a centennial in 2010. (*Washington Park Profile.*)

Pictured from left to right, Jane Craft, Dottie and Robert Wham, and Wayne Knox are among the residents who have worked tirelessly for decades—both in front of the podium and behind the scenes—to make the Washington Park community a better place to live. (*Washington Park Profile.*)

South Denver is fortunate to have both a recreation center (within the park itself) and a community center (located in a former church on South Washington Street). The Washington Street Community Center caters to young and old neighbors with a preschool and extended-day programs as well as a well-stocked kitchen to provide regular lunches for the aging population and "Dinner Night Out" for families. (*Washington Park Profile.*)

WASHINGTON PARK
THE PROFILE

Celebrating
35 YEARS
Oct. 1978-
Sept. 2013

Thanks for
your support!

Since 1978, the *Washington Park Profile* has been providing a collective voice to inform the community and encourage its members to work together. It is but one newspaper to have played this important role over the past 120 years. The printing press is a mighty sword. (*Washington Park Profile*.)

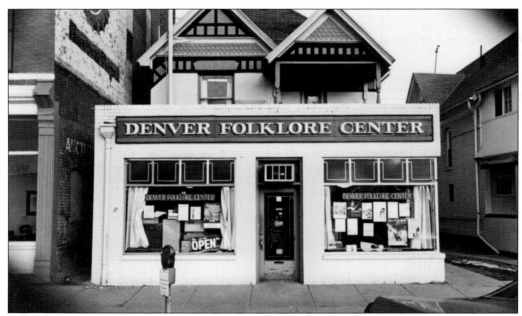

Music has long been a popular form of entertainment in South Denver. From the dance halls along Broadway into the 1950s and the advent of the folk music scene in the 1970s to glee clubs at the high school, music continues to bring the community together. Pictured here is a South Denver fixture that sells and repairs folk and acoustic instruments, the Folklore Center, when it occupied a converted house at 440 South Broadway. (*Washington Park Profile*.)

"'Tis a privilege to live in Colorado" is one of the slogans coined by Frederick G. Bonfils, cofounder of the *Denver Post*. The phrase has risen to the status of an axiom or proverb about Colorado. The beauty of this 1983 view of Mount Evans from Washington Park illustrates this privilege; the view is now protected, the result of neighborhood activism that had its origins in the 1870s and continues into the 21st century. (*Washington Park Profile*.)

Discover Thousands of Local History Books
Featuring Millions of Vintage Images

Arcadia Publishing, the leading local history publisher in the United States, is committed to making history accessible and meaningful through publishing books that celebrate and preserve the heritage of America's people and places.

Find more books like this at
www.arcadiapublishing.com

Search for your hometown history, your old stomping grounds, and even your favorite sports team.